RYAN ADAMS & THE CARDINALS

A VIEW OF OTHER WINDOWS

PHOTOGRAPHS BY NEAL CASAL

RYAN ADAMS & THE CARDINALS

A VIEW OF OTHER WINDOWS

INTRODUCTION BY RYAN ADAMS / AFTERWORD BY PHIL LESH

ABRAMS IMAGE
NEW YORK

INTRODUCTION
RYAN ADAMS

June, 2009, California

Sometimes people just have to look back, even when what is back there is what was left of your youth. That is certainly this book for me. All those parts not being relative to me. All those moments not being mine.

Still, life is water-wet and I have always lived by the river with my head under the falls.

The fog of constant travel makes some of these images very difficult for me to understand. I cannot recall everything here. I get "emotional impressions," really. And mainly what I feel is exhaustion, regret, anxiety, and fear.

I also "hear" some of these rooms again. I want to explain that for a second. Games. Pretending. Disassociating. Listening games. The only way for me to have been able to travel at that rate and sing that many songs and actually be 100 percent invested in the lyrics was to withdraw. I had to back off of everyone and everything. I had a relationship with my online diary (half fiction and half non-fiction, no one who read it knows the difference, not even me) and for the most part, I would just sit in rooms, smoke, and listen. I would listen to the rooms make noise. I would listen for quiet.

Neal's photos remind me of the most engaging moments. In these photos you can see the moments where as people we interacted. These were the moments where we acted like a band and where we forgot the burning days behind and before us and just let loose. But much of life being in the Cardinals was work. And yes, some of that is because I am who I am. I would never want to be the kind of person who avoided attention to detail. I would do things until my will was at a breaking point, be obsessive in my efforts to make the magic come from the invisible ragged moment when the moment should just break around me and collapse. I don't mind that people expect I am difficult. I am. That is what art should demand of its artist, be that a marginally talented songwriter-guitarist (me) or the greatest composer, painter, author, or photographer.

When I see the photos of empty beautiful streets or strangers sitting by a river, I can see Neal more clearly than in my memory of my time with him. I can see him reduced to a curious alien. He holds on to the moment with his camera like a fisherman holding on to a fish after a gentle tug on his line. These photos feel like the moment after the bait is sprung, but before the rod is cast back for the kill. He is uneasy with ease. His questions all come through the lens beautifully, but all questions about himself.

The photo of the man beside the river makes me wonder if Neal was thinking quietly, "When will I sit silently beside a river?" An empty seat, once filled in a photo. He questions the value of a moment. He is thinking with his pictures. He illuminates a person he is not sure how he feels about.

Constant travel and constant challenge of a person's ability to rise up in the face of exhaustion creates the fog. Simple things that bring simple pleasures can become traps. Somewhere in these moments I can hear the sound of the rooms. In those rooms I can hear the muted sounds of those guys through backstage walls, the words gray by the distance, and on the other side the sound of electric things and crowds humming right before take-off, right before the lifting or the sound of music dropping and hitting the floor and breaking into tiny sharp pieces.

Neal photographs the world silently and passively and beautifully. These photos hurt. I see a man tortured, not eating, not sleeping, miserable. I see friendships falling out of the windows of the museum. I see art burning just outside the frame.

Being in the Cardinals was always a long series of wins and defeats. The wins happened in silence and were forgotten. The losses were hung over our heads and

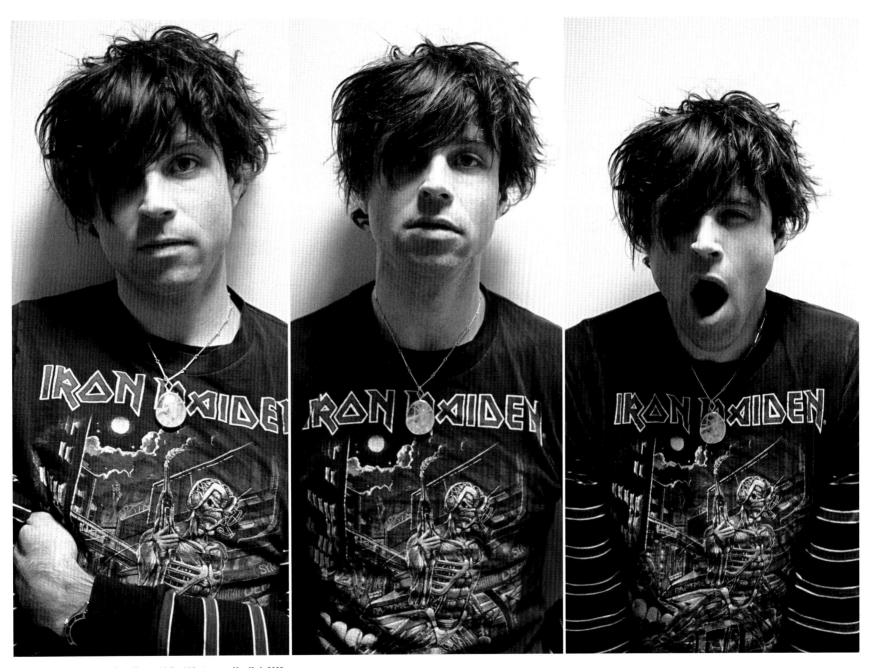

Ryan Adams backstage at the Late Show with David Letterman, *New York, 2008*

pasted in the streets for everyone to see each morning. Every misstep was documented with the fervor and exactitude of an invisible angry mob. While most could ignore the scrutiny, I chose to stay under the miserable cloud like a captain with his doomed ship saluting the sea. People love it when good things fall apart. This is how the new century works for art. It is nothing until it burns.

In the last days of records, of albums, with songs meant to take a listener from one track to the next, not an album as a series of singles—the Cardinals, to me, were wonderful. We made great albums and we even made one damaged real double album. We left every wrong note and flaw. Every song was recorded in its inception so that we might get to the next song and not lose the fuel of inspiration. Those were the shining times for us and I think the power of those moments bonded us like we had witnessed great things that only we could understand. It created a language between us. As a band we were total fools for rock and roll and total suckers—completely optimistic that others would fall sway to the power of whatever it was that bonded us. Nobody wanted to be famous or rich or given any power. We all just thought that maybe we tapped into a hidden pocket of rock-and-roll magic (seriously) in a time when wells were going dry elsewhere. (I think that is sort of cute.)

Anyway, I could never save myself then anymore than I could save someone else

with music. I am helplessly shy, totally reclusive, and even though I have great times with people in quiet, I am just not myself in social situations. I always saw the shows as one more test of my will and my ability to fight my desperate need to just run away. I am made of panic and much of me is made of pain. The songs I write and the way that I convey them would not be the way they are if I were the most well-adjusted theater kid with a few records. I have needed these songs more than anyone else and maybe sometimes even more than they needed me.

If anything, now that the idea of records or albums becomes more obsolete, I hope our contributions remain solid and our little time as a band can be seen for what it was. We were believers and we believed hard.

The last time I looked at these photos I stopped at a photo of me in an airport. I am sitting by myself in shadow and it is raining. I am alone. This is how it felt by the end. This is what it took for me to finish what I needed to do, and looking at that photograph I remember feeling isolated and meaningless. I think I had let go.

I will not miss those times or who we were or those rooms. Sometimes people just have to look back, even when what is back there is what was left of your youth. That is certainly this book for me. I have looked back and now it is yours, this past, to dissect if you choose. I am

happy to have made my exit for a life without the constant measuring, where what I love is not judged by the crowd of faceless and nameless critics.

Be cautious with your dreams. Life is sweet but never long.

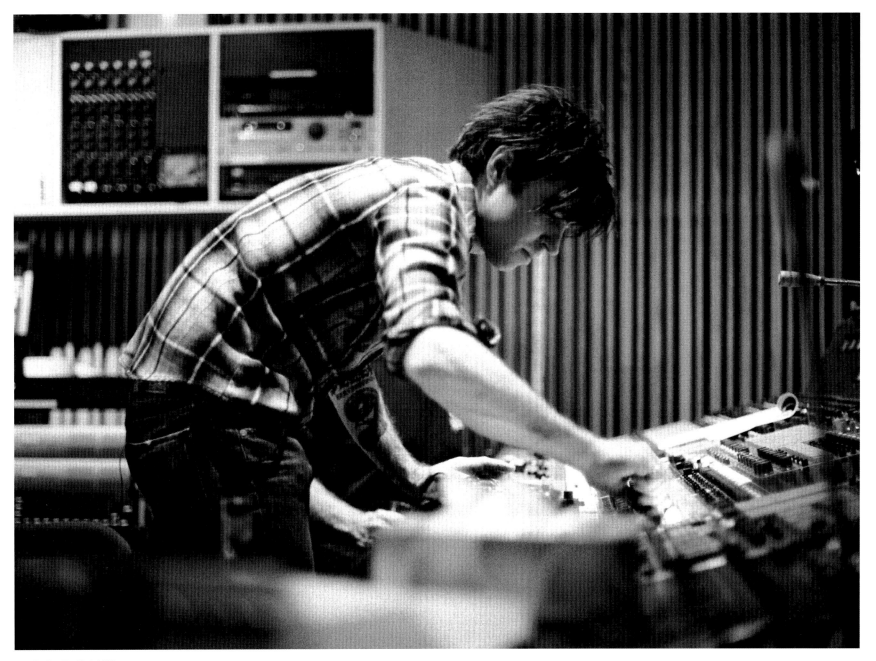

Loho Studios, New York, 2005

The best things happen on the street.

I first met Ryan Adams in March 1997, on a street corner in Austin, Texas. We had a mutual producer in Jim Scott, and mutual friends in a band called Hazeldine, who introduced us. He'd heard my first record, I'd heard his, we talked for a minute, and hit it off right away. He was already writing amazing songs, and you knew instantly that this guy was going on to great things. His presence and wild creative energy were already fully formed. It took less than a second to see it.

Through the years I'd run into him on different street corners and studios in New York, Los Angeles, and even Paris once if my memory serves. In early 1999, Ryan and I ended up playing guitars together late one night at a friend's house and had an epiphany. He leaned a certain way over onto one foot and hit some strange, far-off note that I instinctively recognized. I was already leaning in that direction, and hit a harmony at the very instant his note reached the air. There was some kind of instantaneous flash that defies explanation. We looked over at each other and without speaking knew that one day we'd end up in a band together. The timing wasn't right. He was doing his thing and I was doing mine, but there was this feeling that one day it would happen.

A long time went by and I didn't see him, until one night in September 2005. I was walking down Avenue A in New York City, just in front of Hi Fi, and heard a familiar voice behind me. I turned around to see Ryan coming toward me. Ryan said, "Neal, where have you been? I'm ready now, are you?" Original Cardinals guitarist JP Bowerstock had just left the band and nothing else needed to be said. I was a Cardinal from that moment on.

I wasted no time. I began shooting the band at the very first rehearsal. Guitar in one hand, camera in the other. No one seemed to mind, so I made it a part of my everyday routine. It was an exciting time—so much to process so quickly. My first full show with the band was in Austin: Brad Pemberton on drums, Jon Graboff on pedal steel guitar, and Catherine Popper on bass. (About a year later, Catherine left the band and was replaced by Chris "Spacewolf" Feinstein.) It felt strange, but somehow right, to be back in Austin with Ryan, and now the Cardinals, some eight years later.

At the Cardinals' home base in New York, the pace was dizzying. Lots of late nights spent working my way into the fold. It was a challenge, but I felt up to it. I'd been refining my skills in many different areas for years, and the Cardinals were the perfect band for me. I was learning to play and sing hundreds of songs on the fly, learning the very unorthodox way in which the band works, and photographing it all simultaneously. I became obsessed with the idea of documenting the very band I was playing in. Photographing from the inside out.

There were rehearsals and recording sessions that would last all night and into the next day. I was blown away by Ryan's talent, energy, and blinding dedication to the work. I was equally amazed by the musicianship and tough spirit of the rest of the band. We got tight as a band—and as friends—very quickly. We did months of sessions for *Easy Tiger*. We made the beautifully shambolic *Songbird* with Willie Nelson. We recorded *Follow the Lights* in three inspired days in Los Angeles. Several months later came *Cardinology*. Behind those studio doors are countless recording sessions and songs that remain unheard. Then came the touring. Multiple trips around the world and it all became a road-burned blur.

Writing a great song is everything to Ryan, and he'll stop at nothing to find it. He'll dig as deep as he has to go to get there, and you're either going with him on that journey or you're not. He was dead set on turning the Cardinals into a great band, and it worked. I turned my lens to every moment that I could. He

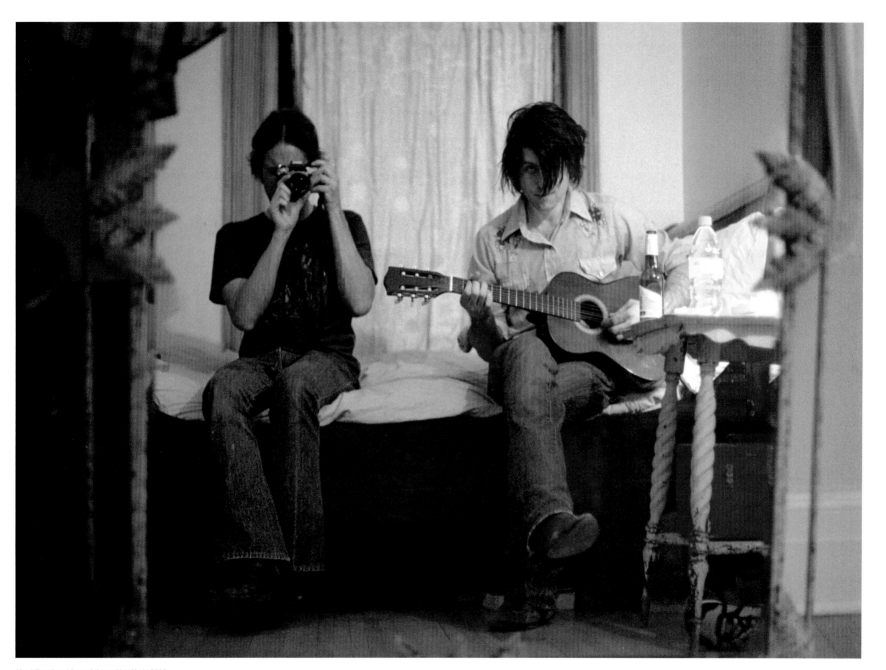

Neal Casal and Ryan Adams, New York, 2005

and the band were perfect photographic subjects, always so deep in the music that they didn't even notice my camera. And if they did, they had enough trust to let me keep shooting. The only thing that frustrated me was that I had to put the camera down when it was time to play music. I missed just as many photos as I got, and those frames are even clearer in my mind than the ones in these pages.

I once read that Garry Winogrand had a wish to "shoot everything that he saw." That resonated with me, and I thought, "I'm gonna do that, too." No mystery, just have your camera and be ready, every day, no exceptions. It makes sense that I ended up in the Cardinals, as Ryan has a similar work ethic. He writes about every single thing that he sees and experiences.

I didn't begin taking photography seriously until I was in my twenties. I'd loved photography since I'd seen some Robert Frank photos as a teenager, but never thought it was something that I could do myself. Playing music was one thing, but photography was quite another. It seemed out of my reach. Years later, my girlfriend gave me an old Polaroid SX-70 and I started tinkering around with it. I used a few of the photos on one of my early solo records. Then, when I began to tour more regularly, she gave me a better camera and my interest began to grow. I found myself doing it every day and falling in love with the process. I'd wake up early just to get into the streets

and photograph anything that interested me. I'd stay out there for hours, shooting roll after roll of film. I still do that. There's nothing better than stepping into the street with my camera, eyes open to the day, and letting it all in. It gradually became something I couldn't live without. I had no idea what I was doing and didn't care. I just let my eye lead the way.

It remained that way until the extraordinary photographer Autumn de Wilde saw a stack of my tour photos and told me that I had a good eye and that I should take it more seriously. It was a great compliment, but didn't sink in until a few months later when her father, Jerry de Wilde, also a great photographer, saw some prints and told me the same thing. It was another revelation, and I never looked back after that. Something changed in me that day. I dived deeply into learning everything I could, and photography became as important to me as music.

I didn't set out making these photos with the intention of doing anything with them. I made them because being in this band was and is such an important part of my life. Ryan gave me so much support right from the start, but the idea of making a book turned into a reality only after a chance meeting with my future editor on the street, in front of Electric Lady Studios in New York, during the *Cardinology* sessions. Proving again that the best things really do happen on the street.

I had never been able to turn my attention to such fascinating subjects on a daily basis before the Cardinals. I had never been granted that kind of access, encouragement, and photographic free rein. I had never been so deeply involved with such great music on so many levels. To be that far inside of something, musically and visually, is a feeling with no equal. Making photographs began as something just to mark time, but now I do it because I must.

Photographs are the songs I cannot write; the music I hear in my head, but can't yet play. I search for something quiet in them, like the space between breaths. Photographing and playing with Ryan Adams and the Cardinals has brought me closer to that music, that space.

Raglan, New Zealand, 2009

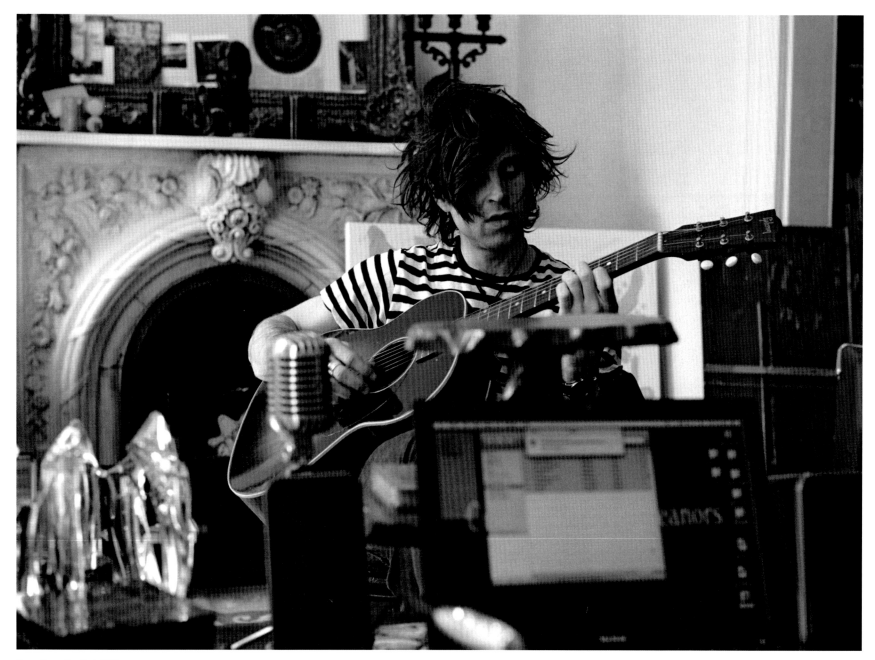

Ryan at home, New York, 2008

I got a call from a piano player who I'd worked with many times and he said that Ryan Adams was doing five or six days in the studio and needed a pedal steel player. I thought, sounds great, when is it scheduled to happen? I was told the day after tomorrow! I did a little schedule massaging and did the session, and those recordings were released as *Jacksonville City Nights*. About three weeks after the sessions, the phone rang, and I was asked if I'd like to join the Cardinals. I said yes. —Jon Graboff

I met Ryan through my relationship with Brad. And then Ryan and I moved to New York City around the same time. We would see each other socially at shows and things. Later, I was invited to hang around during the *Cold Roses/Jacksonville City Nights* sessions and was really blown away by the songs and process. So when the time came a couple of years later that he needed a bass player, I went and played on some demos and just sorta jammed with the guys. It all came together naturally. —Chris Feinstein

Ryan and I met in Nashville in 2000, after he saw me playing a gig at 12th and Porter. Billy Mercer, who was playing bass on the gig, introduced us. He told me that Ryan Adams wanted to meet me. I didn't know the guy. I had heard of Whiskeytown, as my old band Iodine had played the same club circuit down South as they had, so I had seen their name around, but that was the only connection. We met and hit it off right away. We hung out all night and talked music and debated the majesty of Hüsker Dü, the 'Mats, Booker T and the MG's, the Clash, Black Flag, Johnny Cash, the Stones, Cheap Trick, Pixies, and on and on. That conversation has continued for a decade now—and I wouldn't trade it for anything.

The next day we were at a rehearsal room. Ryan was writing what would become *Gold*. We continued playing together under various names up until 2003—LAX, Sweetheart Revolution, Pinkhearts, it was all basically the same band, only the names had changed. We had always discussed forming a band like the Cardinals, but we had to find the right people at the right time. After Ryan made *Rock N Roll*, and suffered a shattered wrist, he called me and said he was ready to start the band we had discussed years earlier. I was in, but of course our first gig was in Bilbao, Spain, about forty-eight hours before I was supposed to get married. Fortunately, I have a very understanding wife, and was able to make the gig and the wedding. Been here ever since. —Brad Pemberton

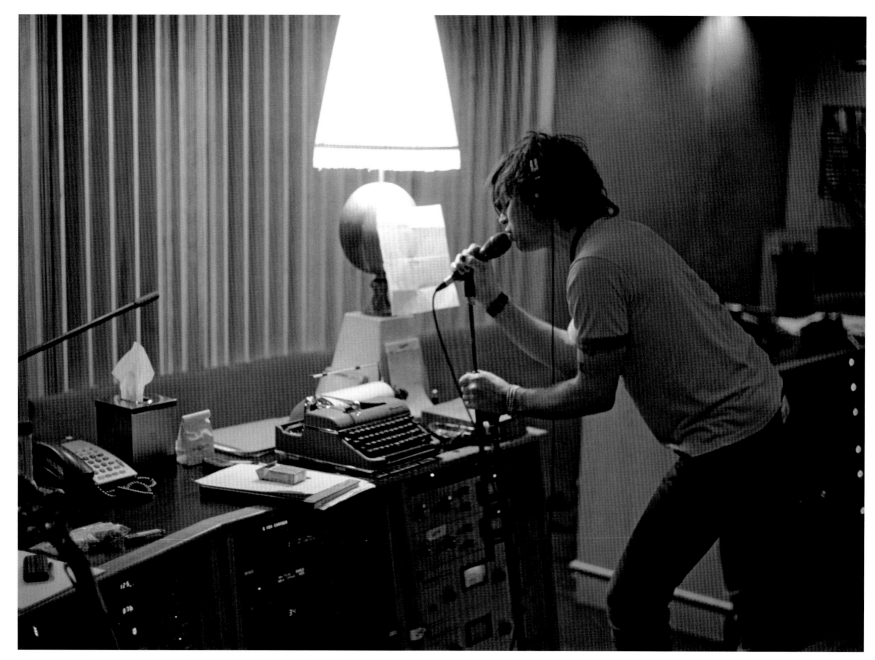

Easy Tiger *sessions, Electric Lady Studios, New York, 2006*

In the studio, Ryan will often write a song and record its final version immediately after finishing the lyrics. He sings his vocals in the control room rather than a vocal booth so there is no lag time between writing and recording. If he's not completely sure of the words, he'll read straight from his typewriter and freestyle where the blanks exist. It's a truly spontaneous approach that's always amazing to be a part of. –Neal Casal

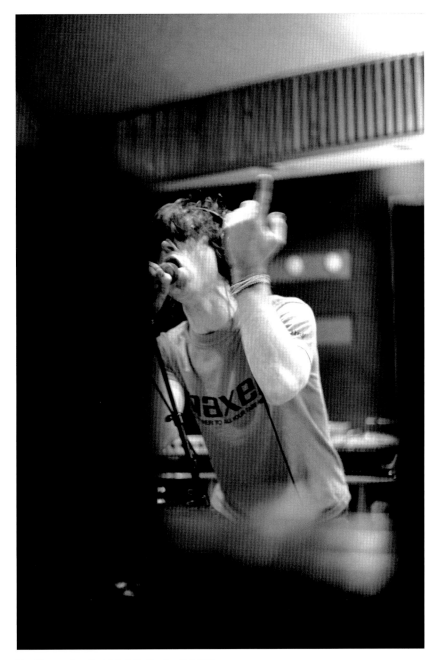

Easy Tiger *sessions, Electric Lady Studios, New York, 2006*

Birmingham, England, 2008

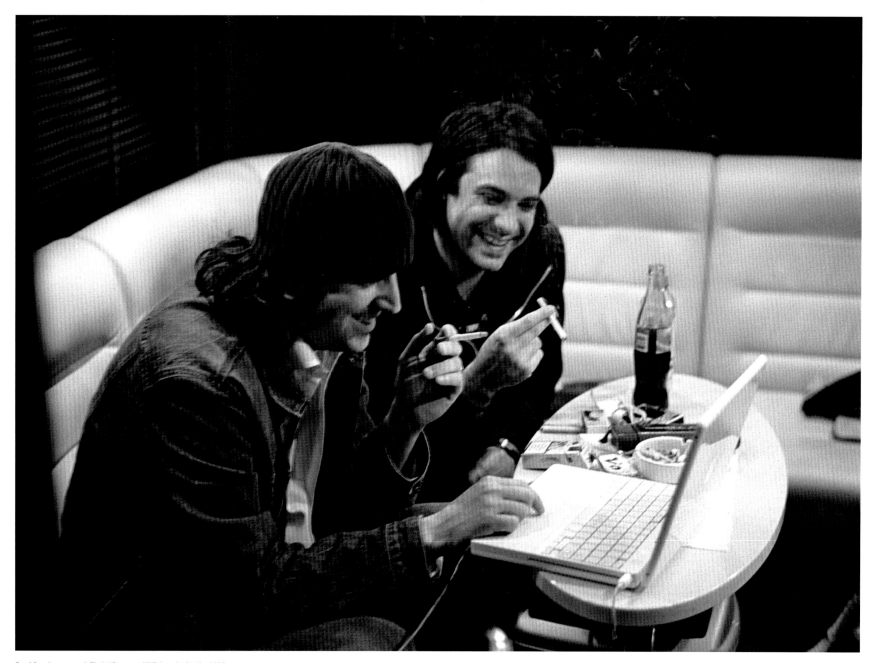

Brad Pemberton and Chris "Spacewolf" Feinstein, Berlin, 2007

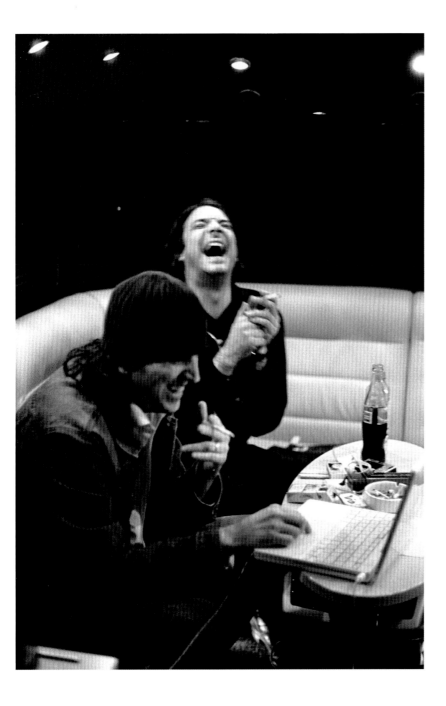

Brad Pemberton and Chris Feinstein both hail from Nashville and have been playing in bands together for close to twenty years now. They've been through everything together, and this closeness shines through in their telepathic musicianship with the Cardinals.
—Neal Casal

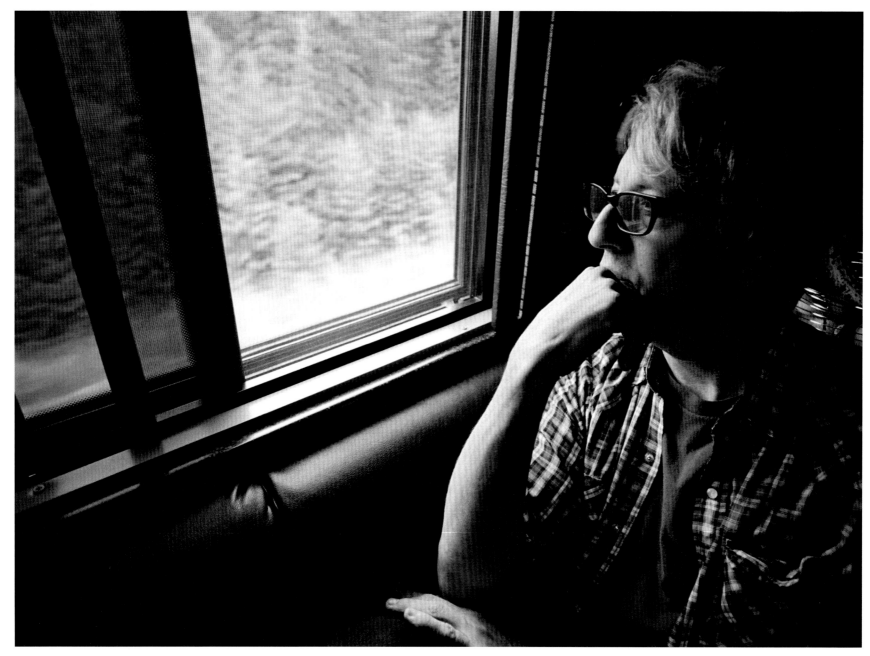

Jon Graboff on the bus in Canada, 2008

Jon Graboff is a dyed-in-the-wool New Yorker and one of the best pedal steel players on the planet. He's completely redefined the role of the instrument in rock music and plays many other instruments with equal talent and inspiration. The band wouldn't be the same without the colors, shapes, and textures that he brings to the music. Funny dude, too. The evening joke with Jon Graboff became a staple of our live sets. No show ever seemed complete without it. –Neal Casal

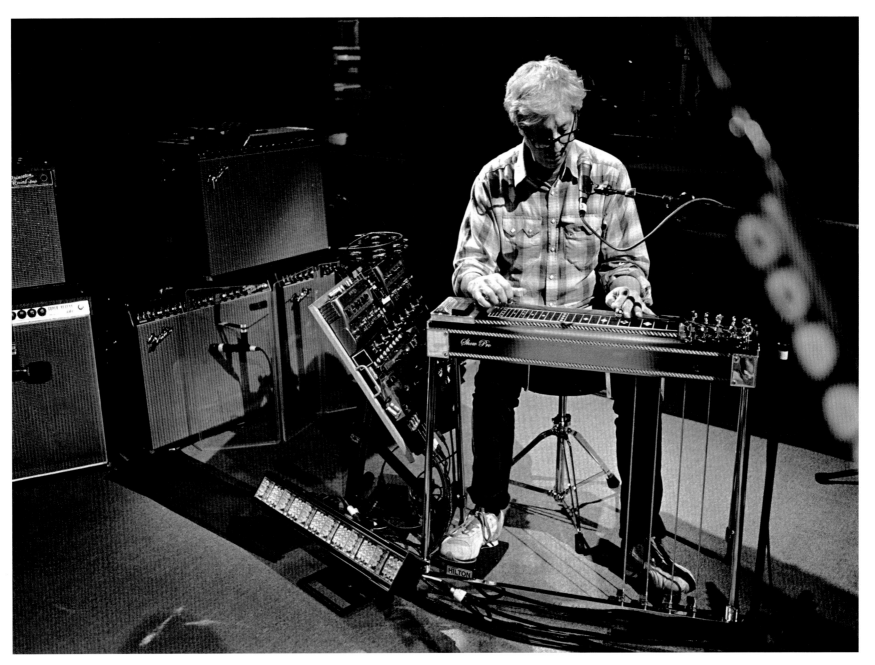

Cambridge, England, 2008

I think a musician is good when his instrument becomes a natural extension of his personality. The sounds that a good musician plays are not only his part of the harmonic structure of the song, but also the information and emotion that they carry. –Jon Graboff

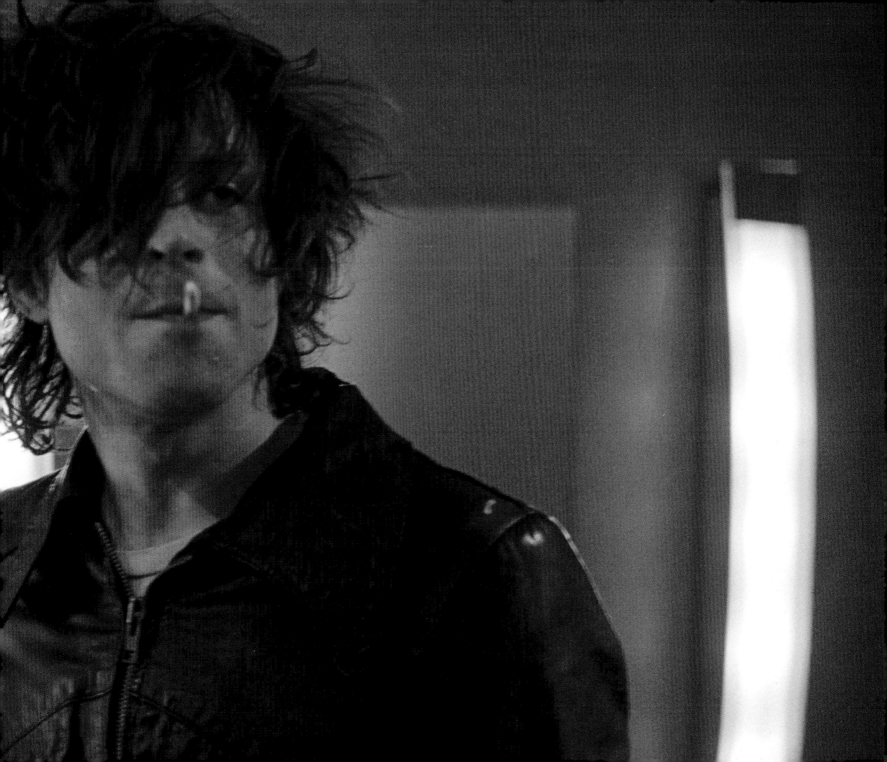

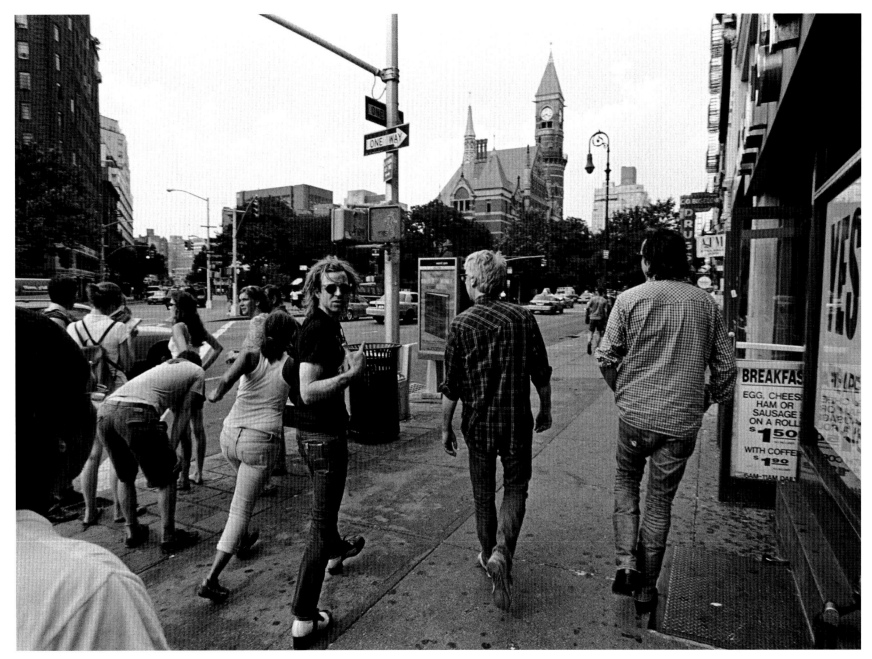

New York, 2008

Previous page: Glasgow, 2006

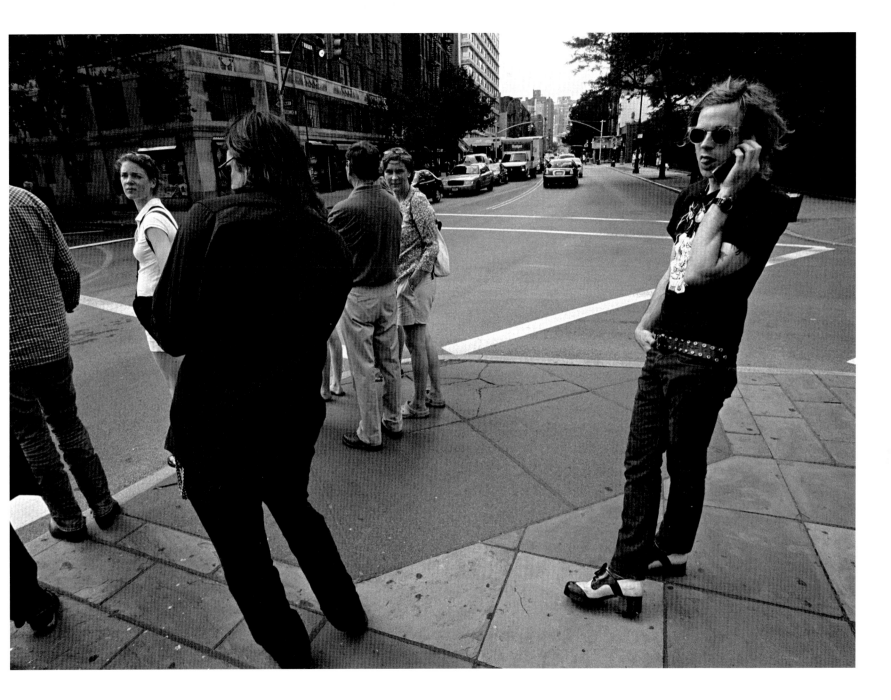

Cambridge, England, 2008

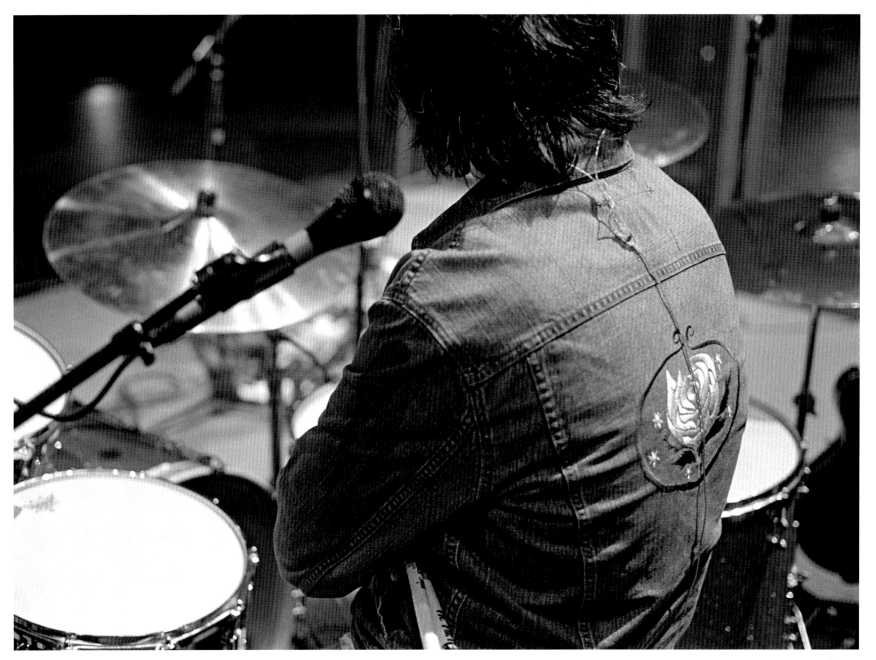

Brad Pemberton, Rochester, New York, 2008

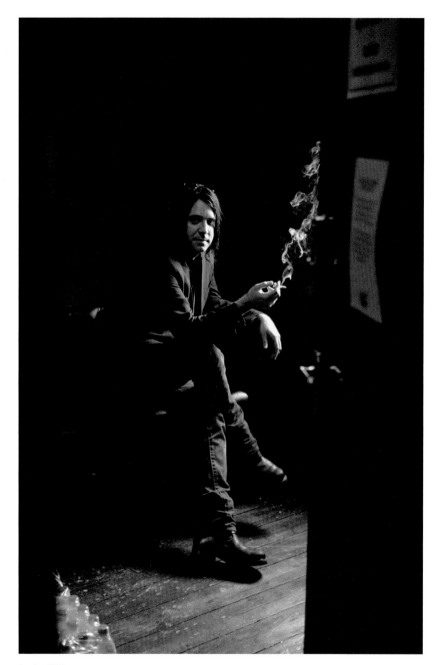

London, 2007

It was my first day of rehearsal at Electric Lady Studios in New York City for the *Easy Tiger* sessions. We were all sitting in the lounge area and George W. Bush was giving a speech on TV. I remember being a smartass and mocking him, saying (in an imitation of Bush), "There's a Spacewolf in my yard." At the same time, Ryan walked through the room laughing and asked, "Did you just say 'Spacewolf'?" Then he said, "That's it. From now on, you're Spacewolf." And so it goes. That was the birth of Spacewolf. —Chris Feinstein

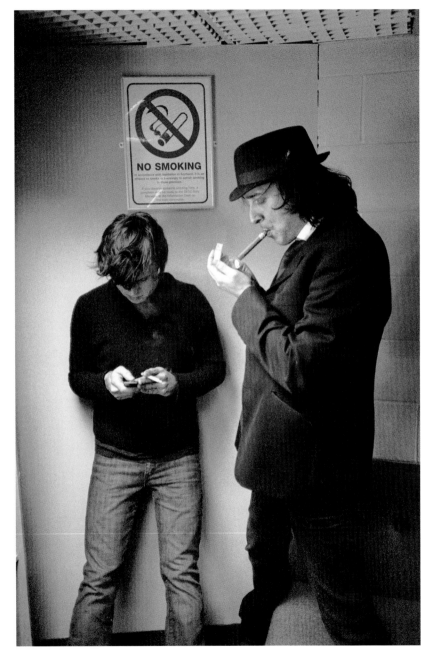

Last night of the Easy Tiger European tour, Glasgow, 2007

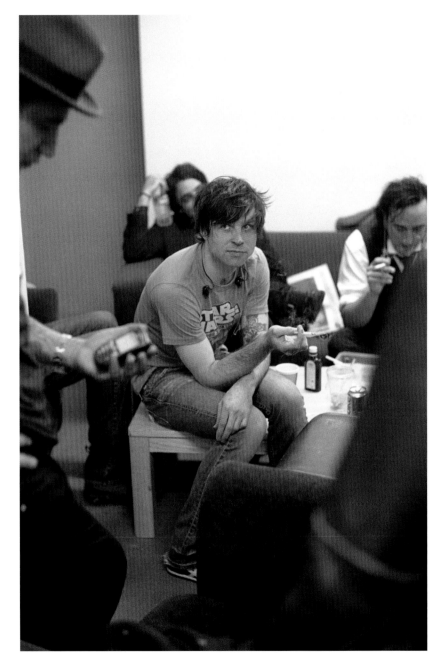

Dublin, 2007

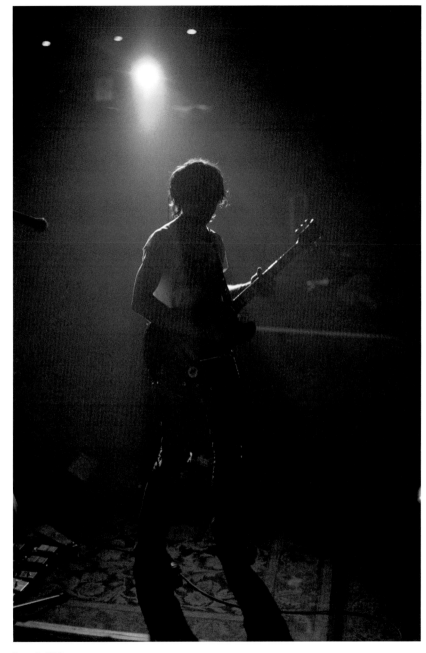

Brussels, 2006

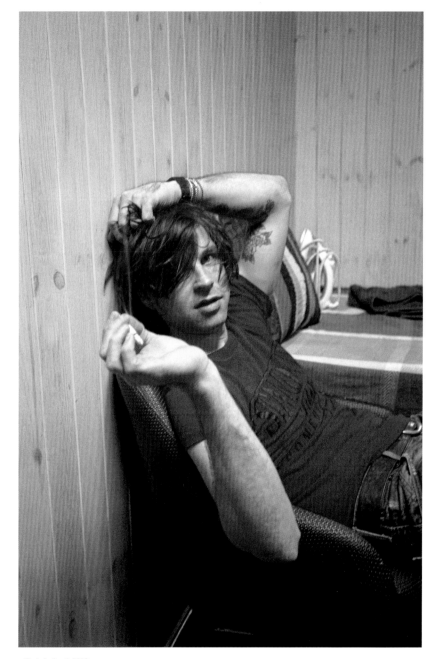

Cork, Ireland, 2006

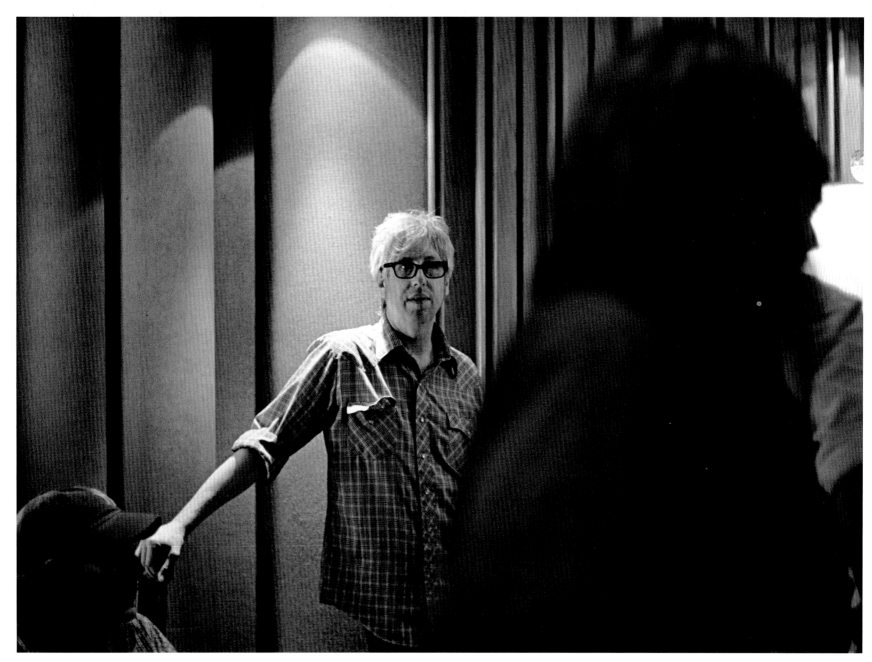

Cardinology *sessions, Electric Lady Studios, New York, 2008*

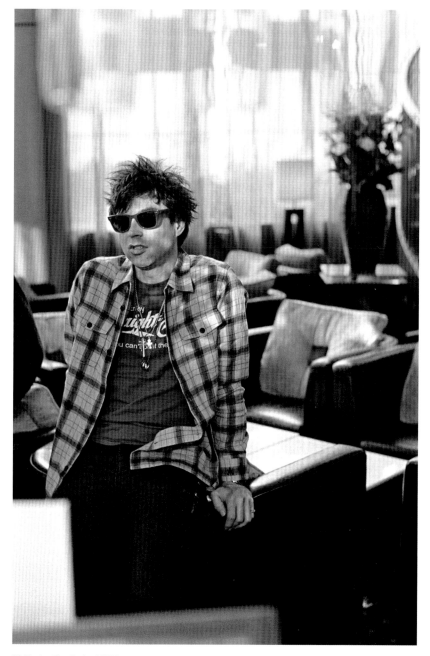

Wellington, New Zealand, 2009

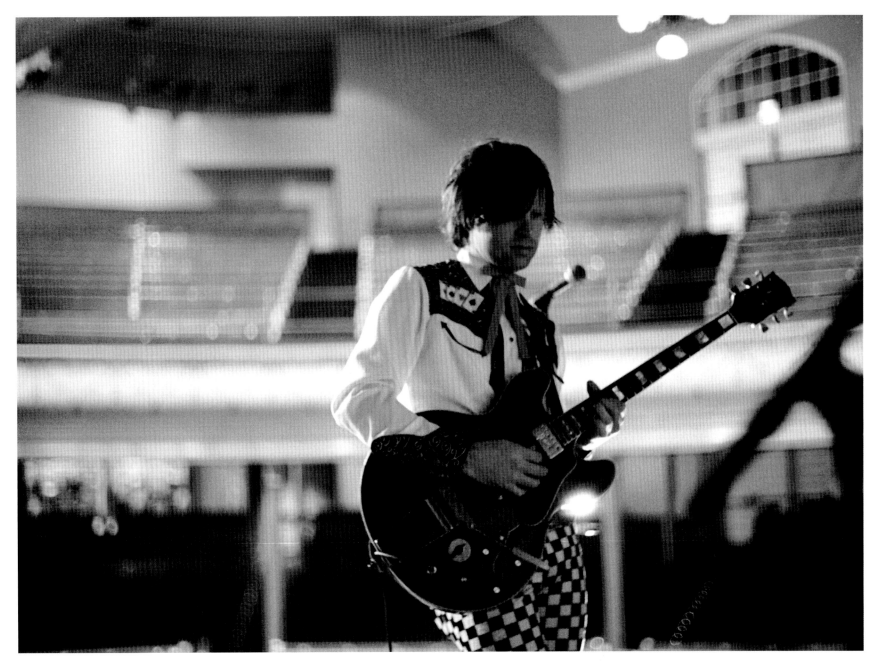

Soundcheck at the Ryman Auditorium, Nashville, 2006

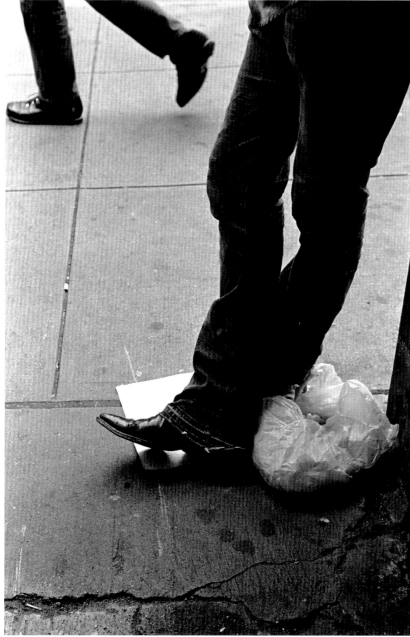

Brad Pemberton, New York, 2005

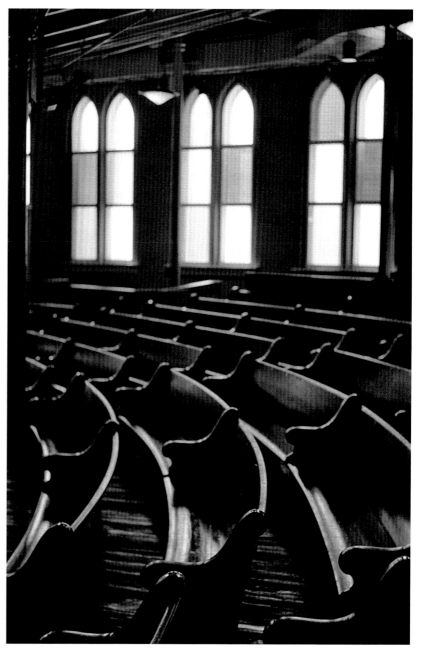

Ryman Auditorium, Nashville, 2006

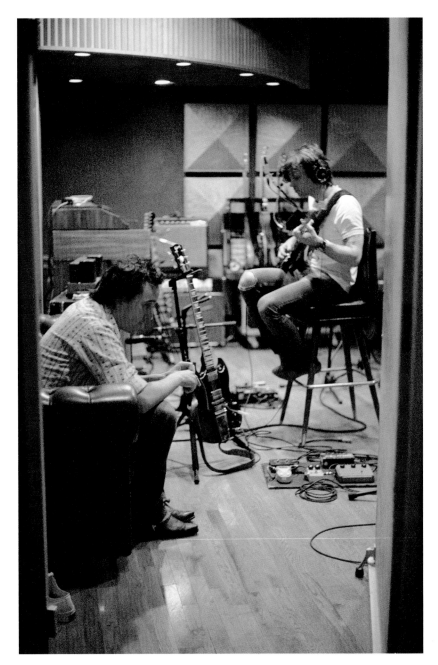

First day of the Easy Tiger *sessions, Electric Lady Studios, New York, 2006*

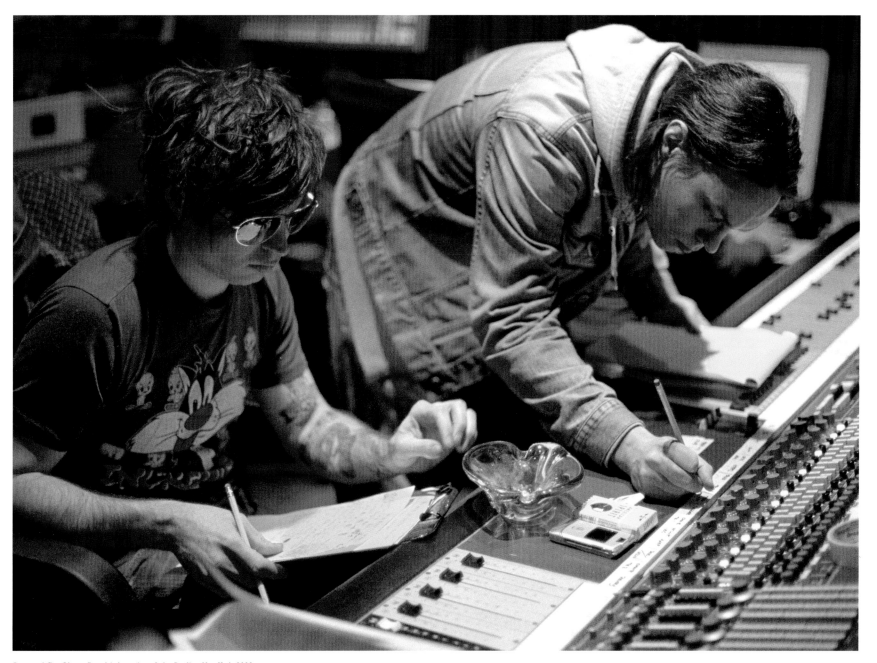

Ryan and Gus Oberg, Songbird sessions, Loho Studios, New York, 2006

Dublin, 2007

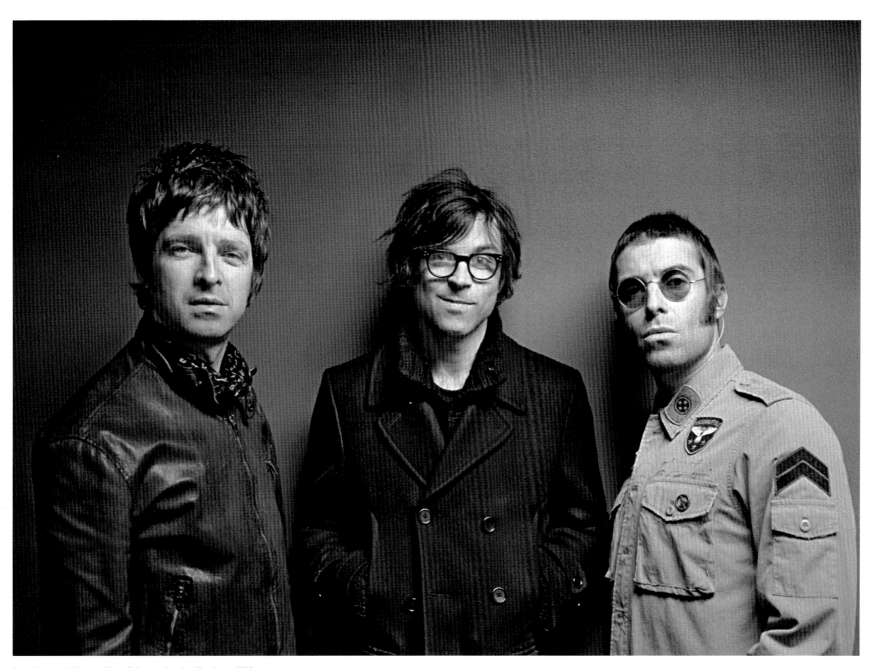

Ryan Adams with Noel and Liam Gallagher, Camden, New Jersey, 2008

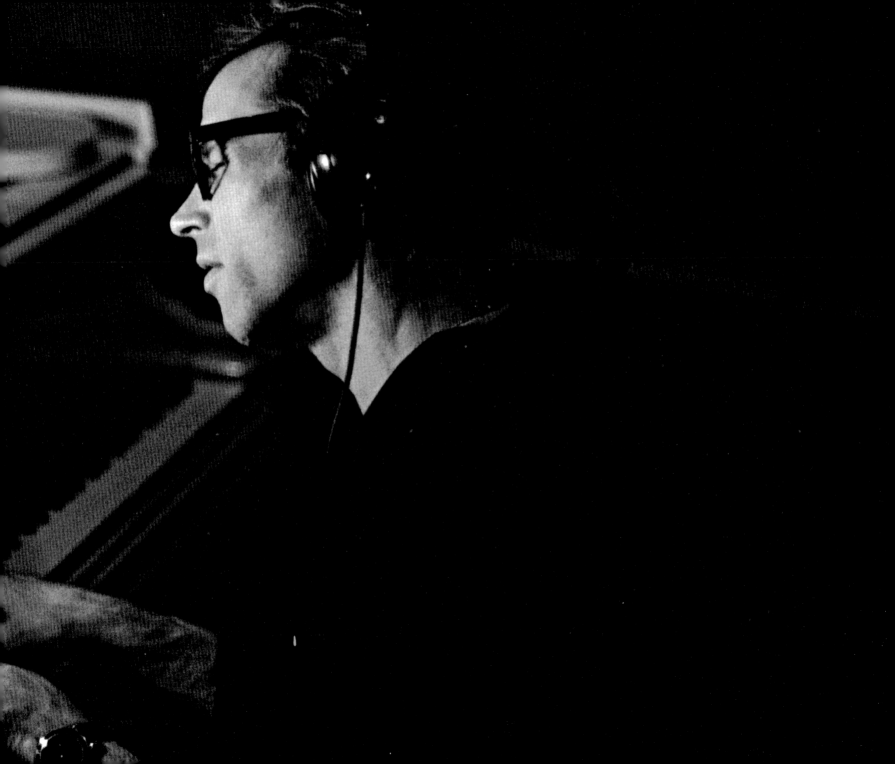

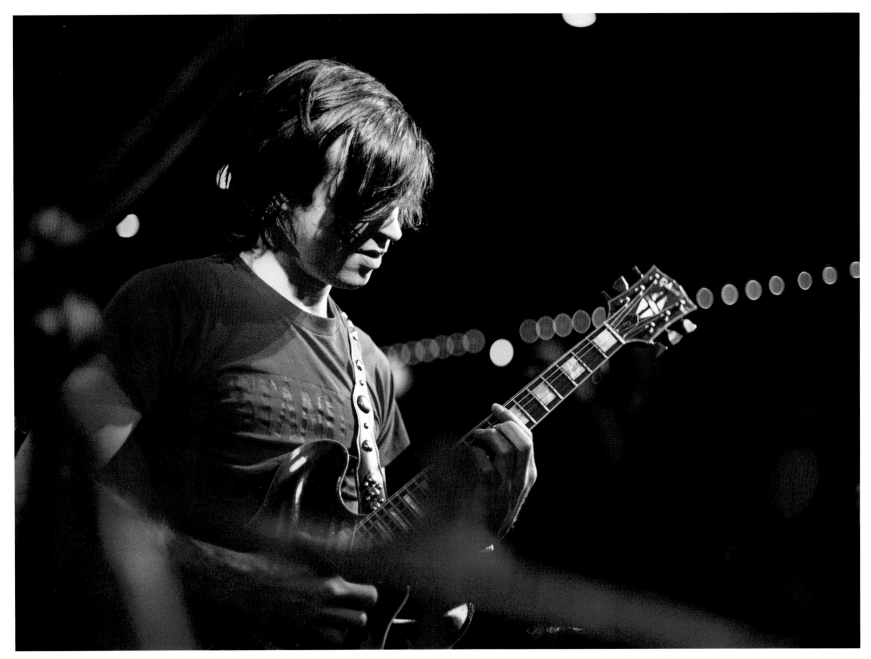

Amsterdam, 2006

Previous page: Ryan writing "Stop," Cardinology sessions, Electric Lady Studios, New York, 2008

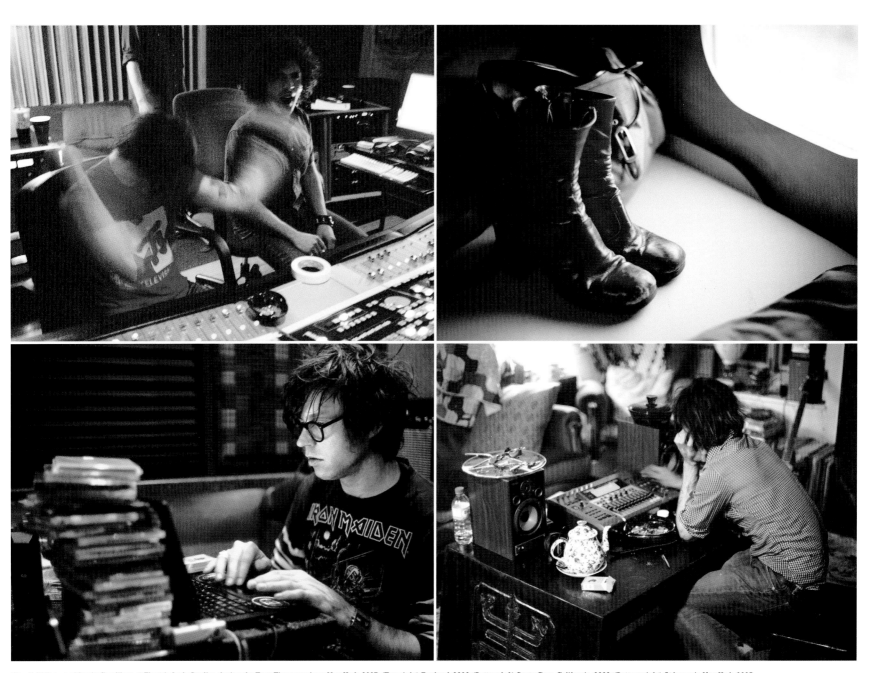

(Top left) Ryan and Jamie Candiloro at Electric Lady Studios during the Easy Tiger sessions, New York, 2007; (Top right) England, 2006; (Bottom left) Santa Cruz, California, 2008; (Bottom right) At home in New York, 2005

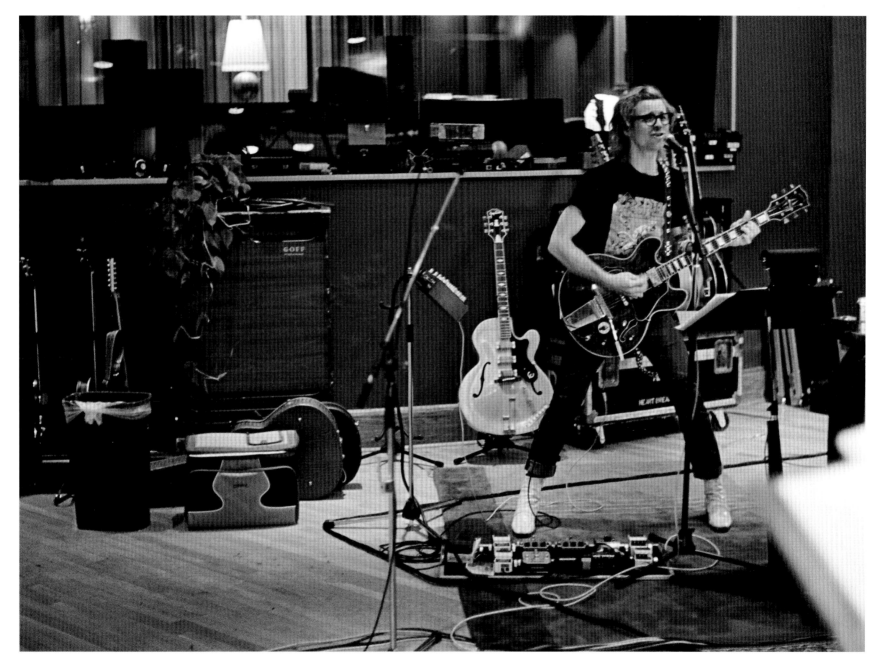

Cardinology sessions, Electric Lady Studios, New York, 2008

There's recorded music and there's live performance and we tend to think of them as separate. We usually record these tunes without a lot of rehearsal so that we hit it with that first blush of excitement and edge—that's where real magic lives. In moments like that, you're in reactive mode, not trying to remember something you came up with in a previous take or earlier rehearsal. You may think you're in the moment, but you're using a different part of your brain and it's not quite the same. There's a loss of immediacy and edge.

Inevitably, as you perform these same songs night after night live, they can start to lose that edge. What better way to keep them fresh, than to let them evolve and change—improvise new intros or endings, or jam on them a little? It's like trying to create that sense of playing the song for the first time. Changing tempos and arrangements on the fly keeps it exciting for us, and I think it has to be more exciting for an audience as well. Rarely do we play the same way twice. —Jon Graboff

The songs change in a live setting every time we play them—that is the most exciting part of performing. We want to keep ourselves interested and in the moment and hopefully the crowd is willing to take the ride along with us. —Chris Feinstein

Because most Cardinals songs are born in the studio, the evolution of the song from the studio to the stage is often quite dramatic, especially to an audience member who is expecting to hear the song as it is on the record. Ryan loves to capture that moment in the studio when the uncertainty we have about a song can either free us up to create something magical or come crashing down like a house of cards. Once we have been playing them for a few months, though, we can create monster rock songs out of quiet little gems, make a straight-ahead song a shuffle, or take the rock song on the record, quiet it down, and find an entirely new feel and meaning to it. That's the beauty of a great song, and the magic of great musicians all tuned in to the same frequency. MFCs. —Brad Pemberton

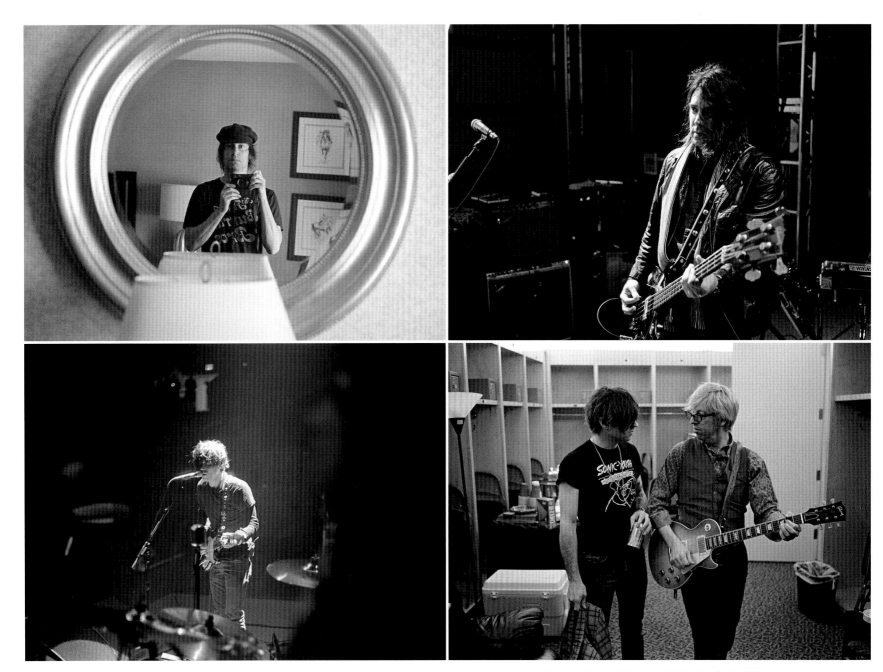

(Top left) Louisville, Kentucky, 2007; (Top right) Cambridge, England, 2008; (Bottom left) Playing "Crossed Out Name" at Madison Square Garden on the Oasis tour, New York, 2008; (Bottom right) London, Ontario, 2008

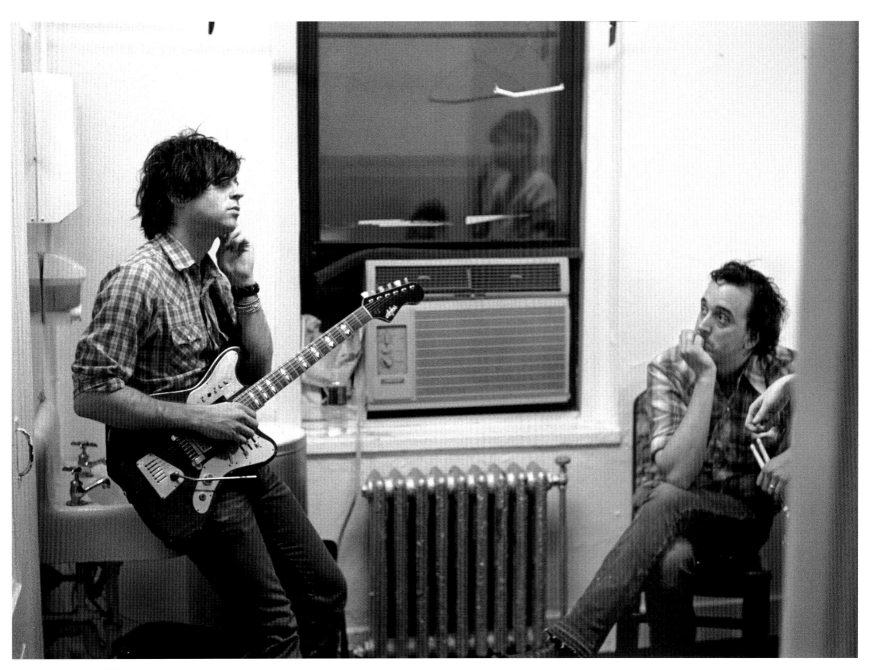

Beacon Theatre, New York, 2006

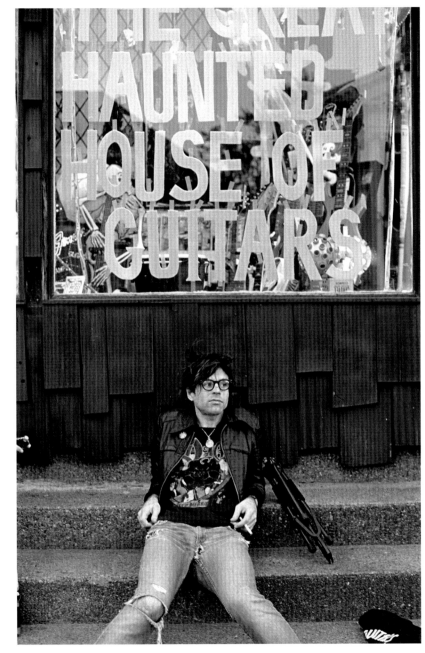

Rochester, NY, 2008

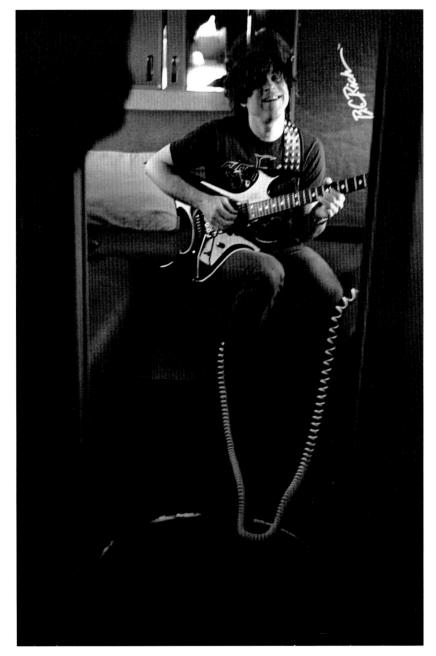

On the bus in the Midwest, 2007

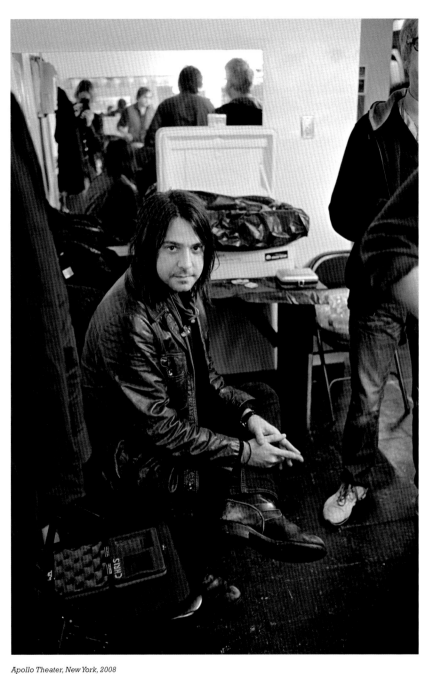

Apollo Theater, New York, 2008

This is the most accurate depiction of the game face. The moment when nothing else matters. I'm about to play the fucking Apollo! What? Dream come true. –Chris Feinstein

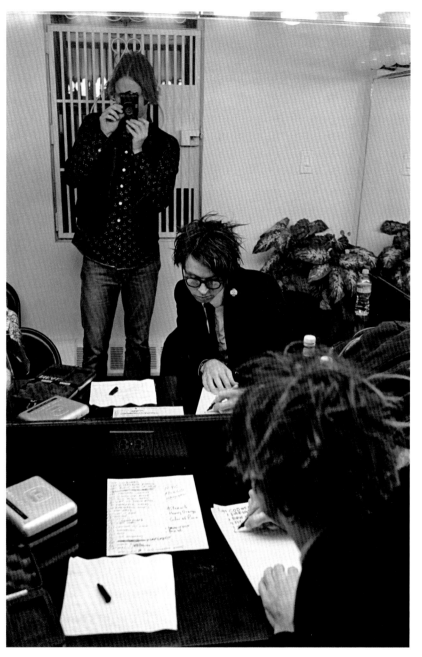

Apollo Theater, New York, 2008

When you're touring, waiting is what you do more than anything else . . . and you wait for almost everything. You wait in the lobby of the hotel for the driver to show up to take you to the venue, or for everyone to come down from their rooms. You wait while the crew readies the stage for soundcheck. You wait between soundcheck and showtime. And you wait until it's time for the bus to pull away and start the drive to the next city. You wait again for the hotel rooms to be ready, so you can take a shower. Lots of waiting.

Does this have an effect on the creative process? Sure. But part of the job is to deliver a consistent performance, regardless of how much you hate waiting for things to happen. Waiting can make you so eager to perform that an explosion of energy can happen once you do get out there in front of an audience, and that can be fantastic. It can also make you feel just plain tired, apathetic, and deflated. But there's a job to be done and we're supposed to be professional entertainers. Don't feel in the mood? Too damn bad. Feel so antsy that you hit the stage and play everything at twice the normal tempo? That's not so great either. —Jon Graboff

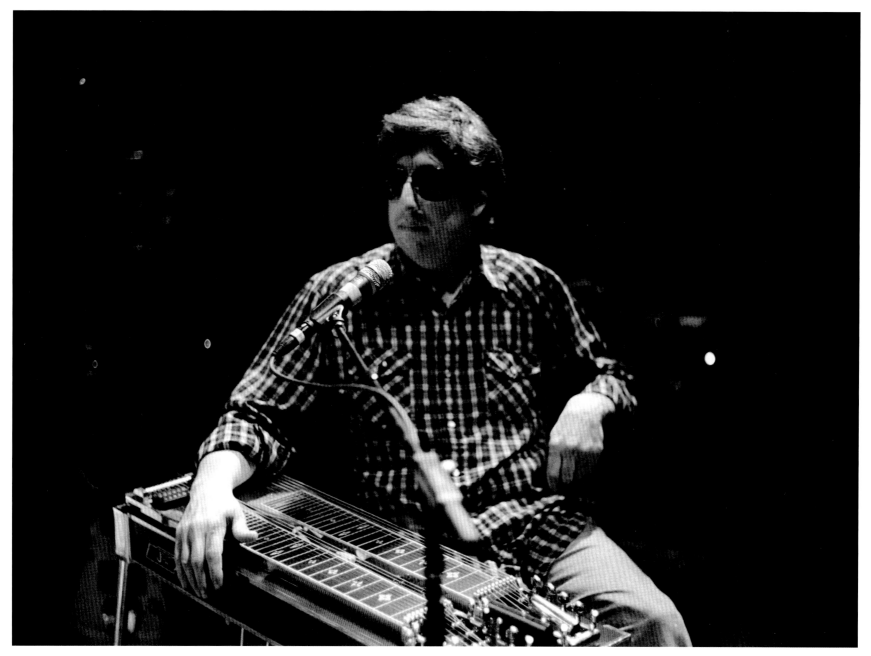

Ryman Auditorium, Nashville, 2006

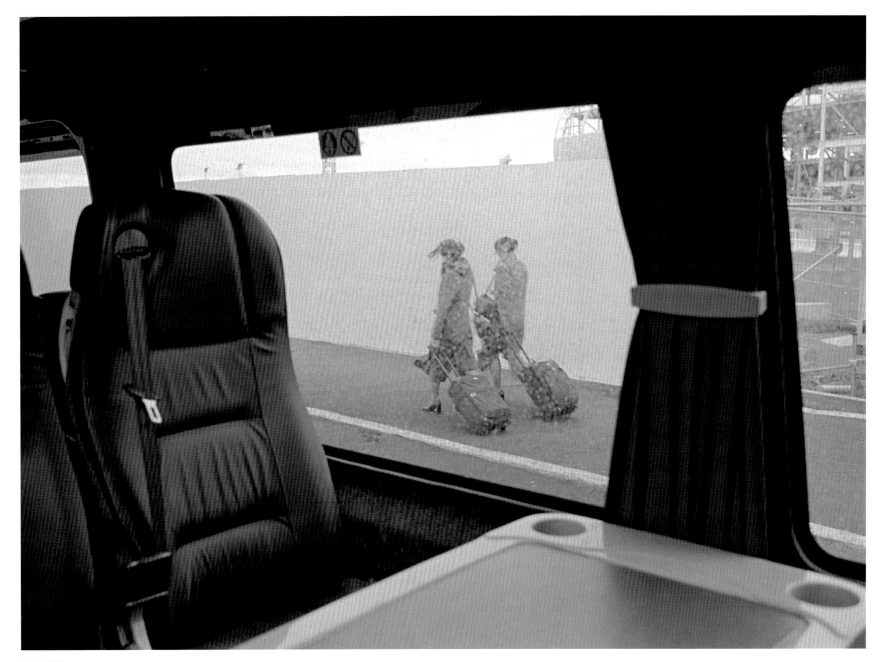

Dublin, 2008

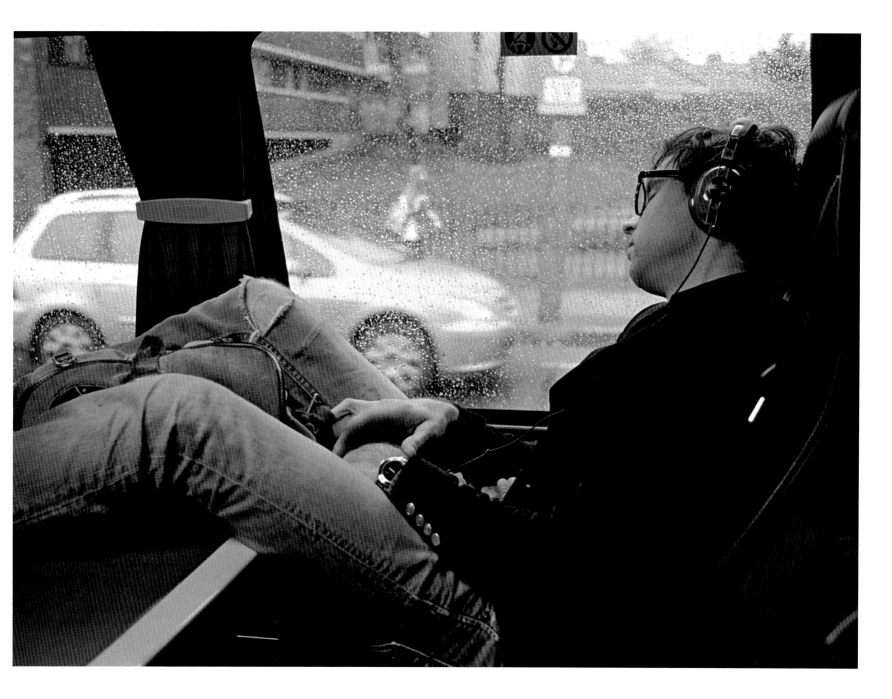

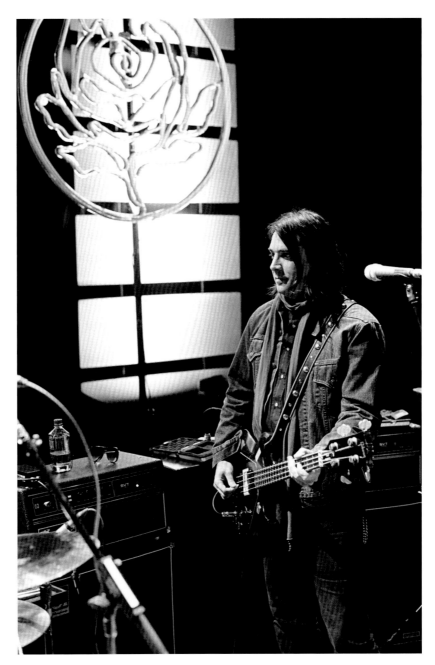

Indianapolis, 2008

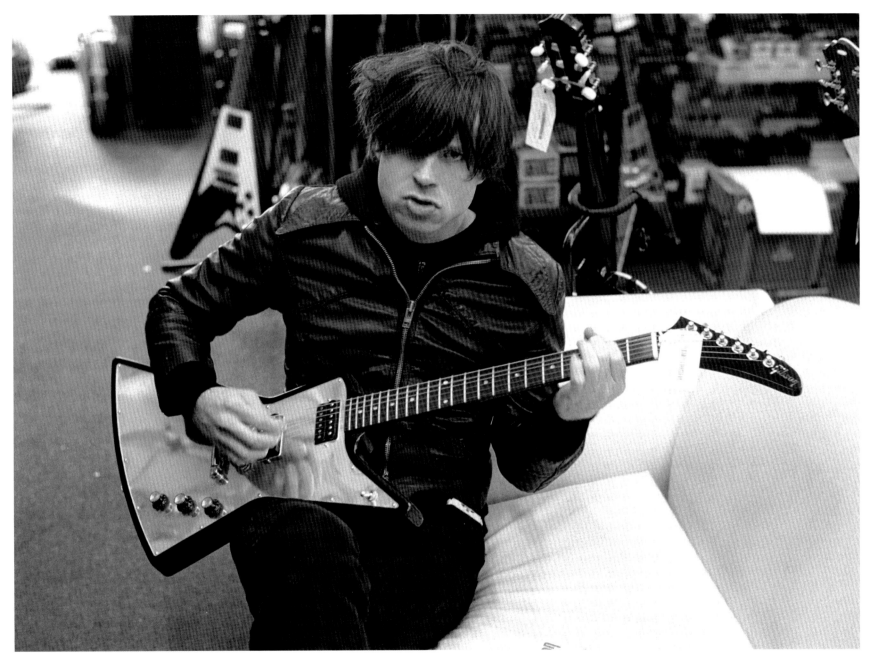

Metal dreams in Melbourne, 2007

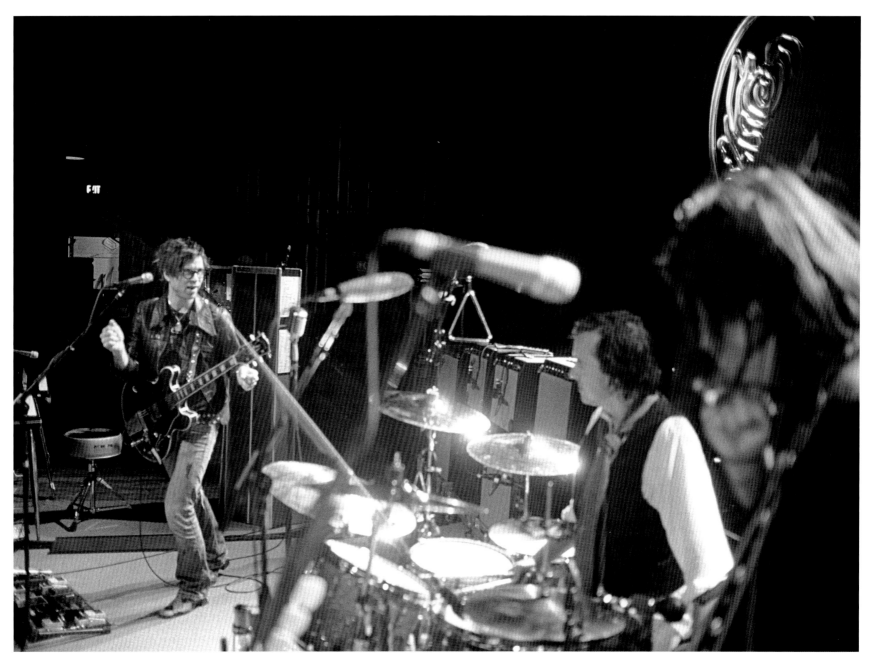

Rochester, New York, 2008

This photo represents the game that I've been playing with Ryan since day one. It basically involves Ryan trying to throw me musical curveballs, or friendly little taunts and jabs, which I have pretty consistently knocked out of the park! Ha! I also see his boundless energy and endless enthusiasm for everything he does, as well as my patience and calmness, which tends to balance him out. When we get "locked" into a jam, we both get this shit-eating grin on our faces—it's what makes me love him and this band so much. We have that Keith Richards-Charlie Watts thing going on. Keith is over there, playing and doing his signature "Keithisms," and Charlie always has that bemused, shaking-his-head look on his face. I used to think that was just their thing, but I get it now. You can't buy it and you can't fake it. It's the real deal. —Brad Pemberton

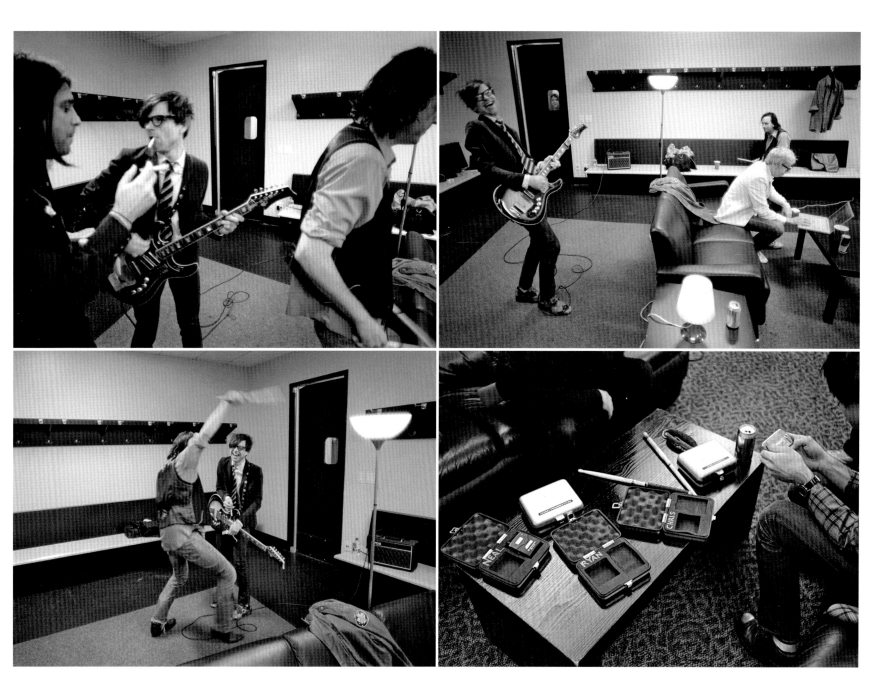

Backstage on the Oasis tour, Ottawa, 2008

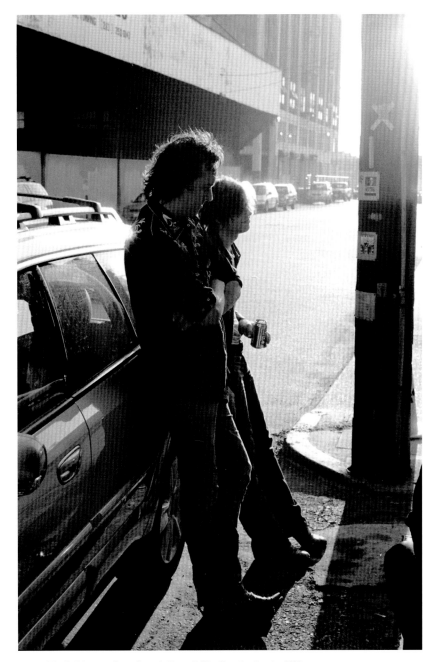
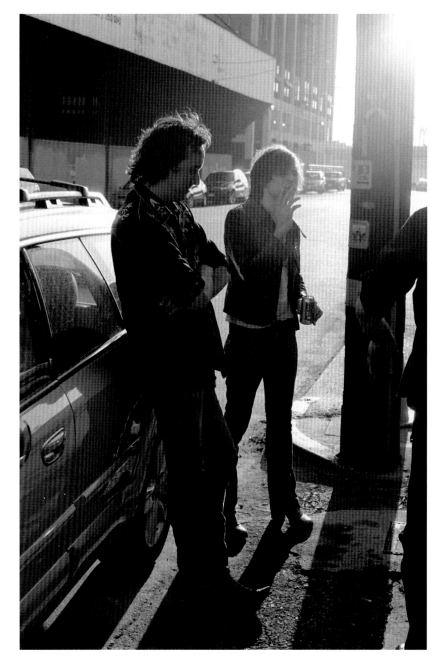

Ryan and Brad talking over the set list at the Henry Rollins Show, *Los Angeles, 2006*

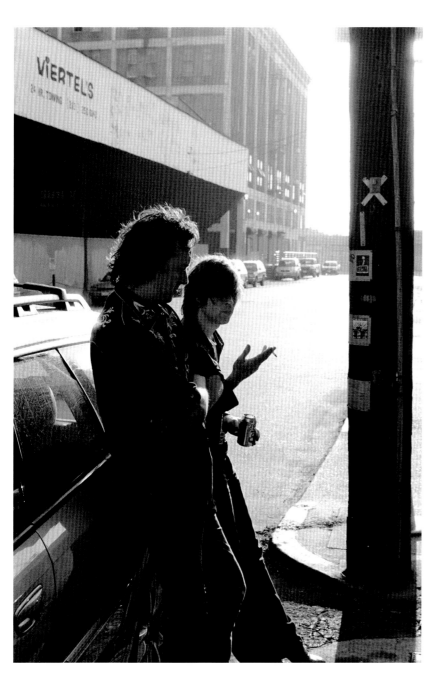
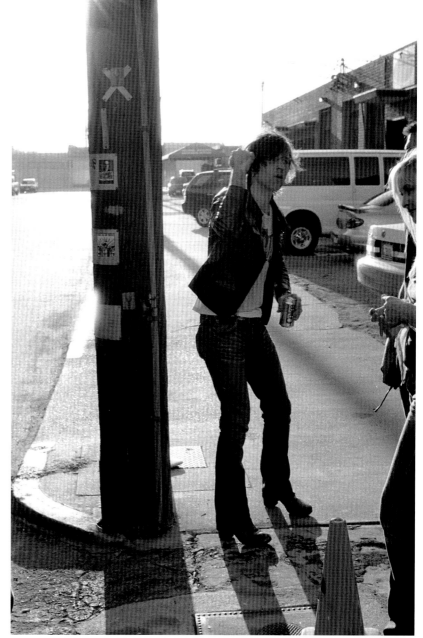

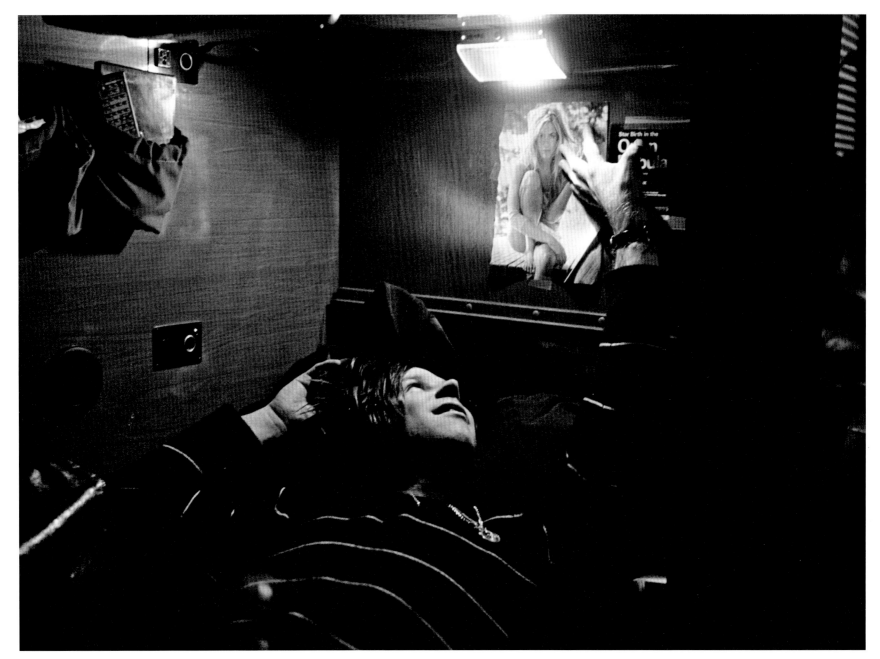

Detroit, 2008

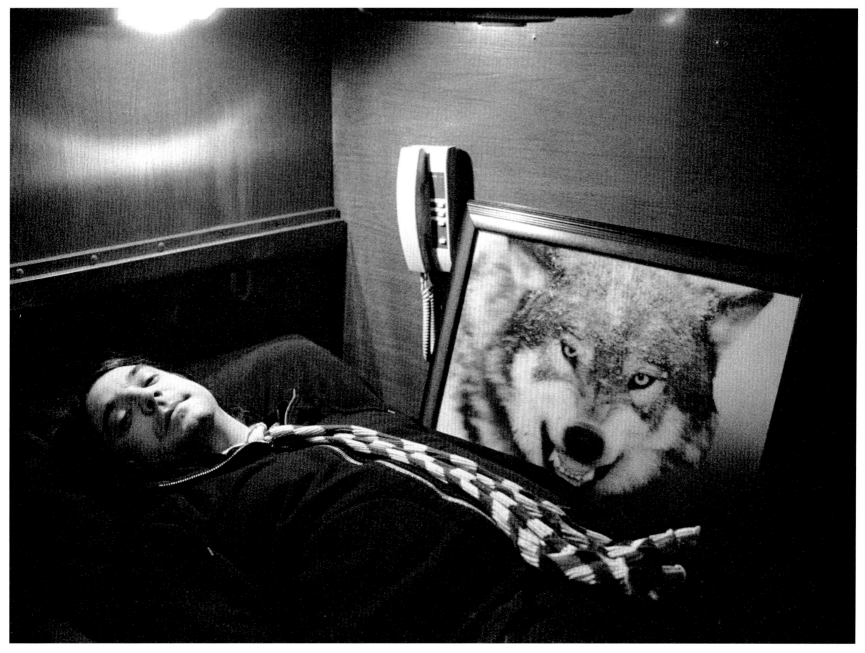

Fairfax, Virginia, 2008

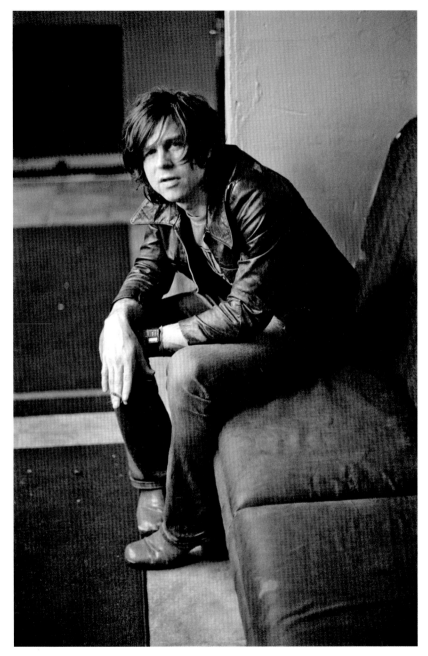
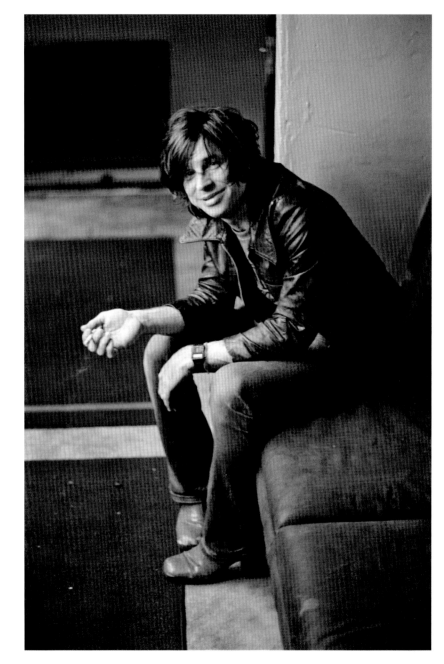

Nottingham, England, 2006

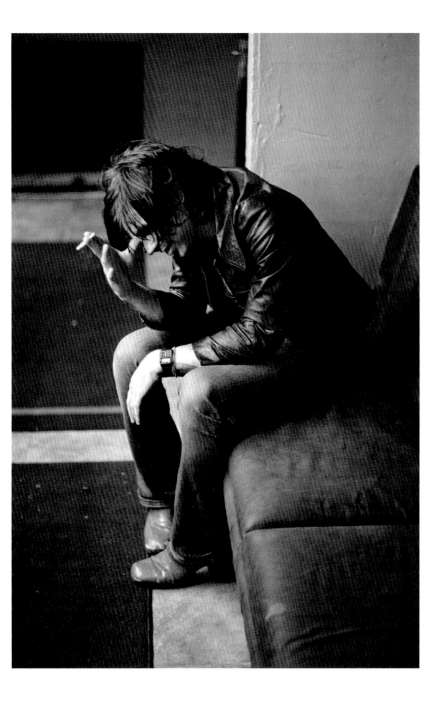

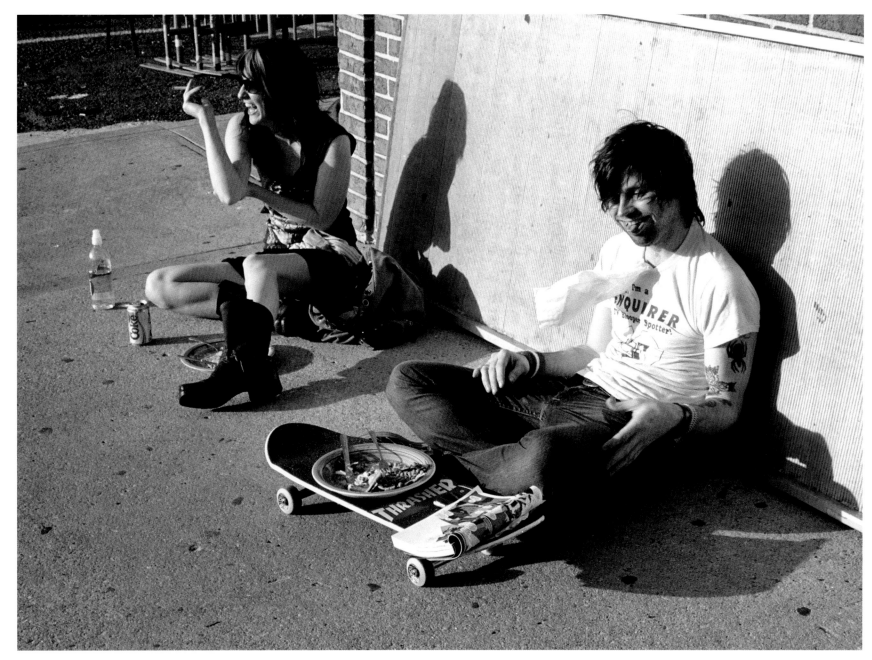

Ryan and Catherine Popper after soundcheck at the Starland Ballroom, Sayreville, New Jersey, 2006

Catherine was the Cardinals' original bass player, whose playing and singing were essential to the *Cold Roses*, *Jacksonville City Nights*, and Willie Nelson *Songbird* records. Her talents were a huge part of the band's early development, and set the stage for where the band would go when Spacewolf came aboard. –Neal Casal

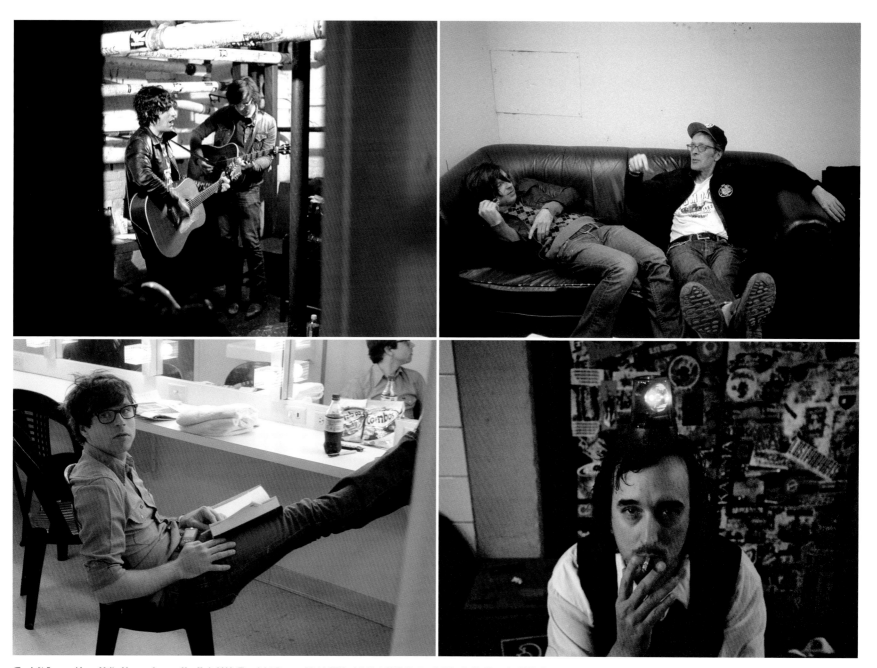

(Top left) Ryan and Jesse Malin, Mercury Lounge, New York, 2006; (Top right) Ryan and Robie Willard, Belfast, 2006; (Bottom left) Louisville, Kentucky, 2007; (Bottom right) Munich, 2006

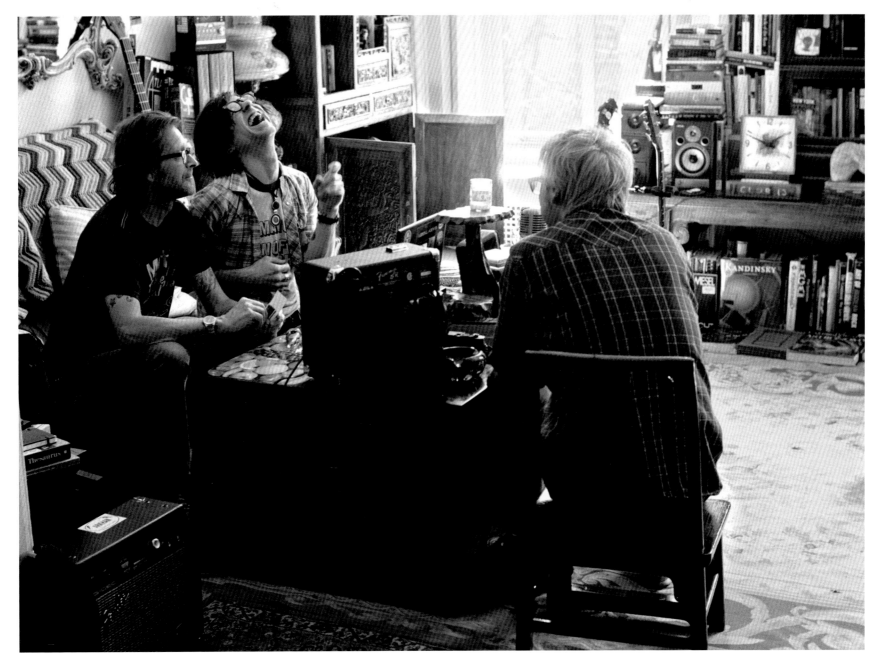

New York, 2008

Graboff, Robie Willard, and I stopped over at Ryan's one day in the spring of 2008 to hear the demos for what would become *Cardinology*. He'd spent the winter break working really hard on his songwriting, and this was the day we first heard "Cobwebs," "Sink Ships," "Magick," and lots of other great songs that would end up on the record. –Neal Casal

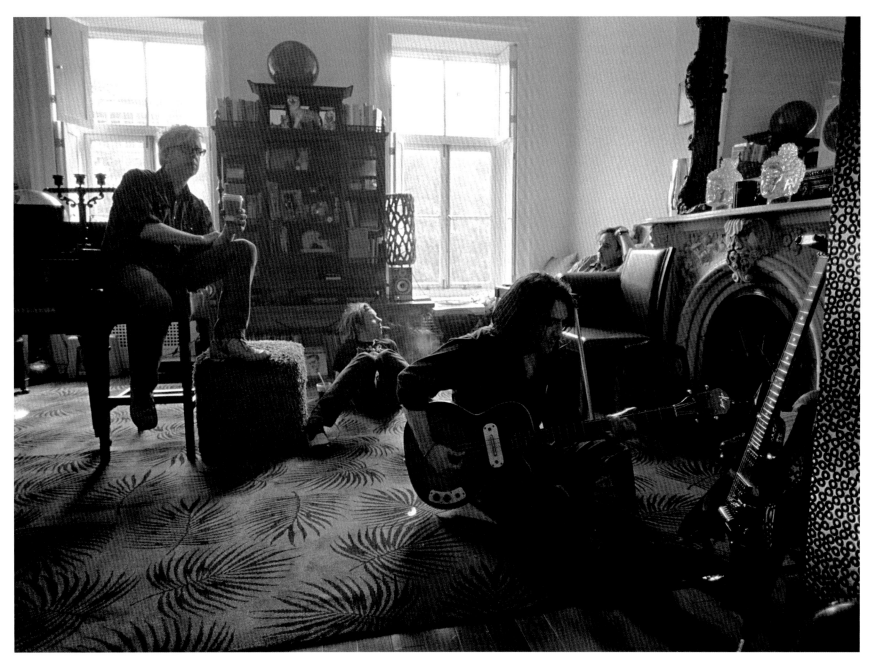

A break at Ryan's house during the Cardinology sessions, New York, 2008

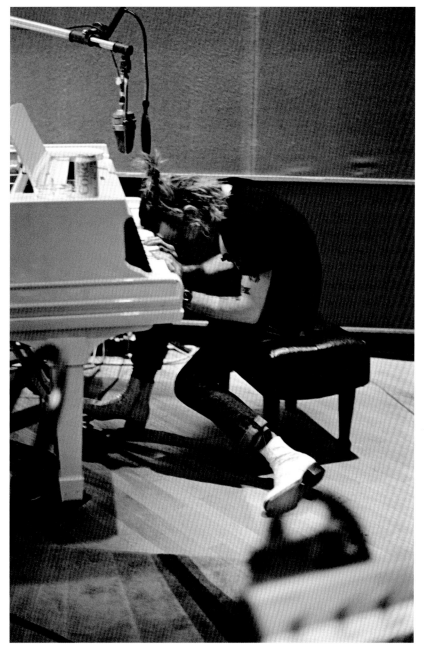

Cardinology *sessions, Electric Lady Studios, New York, 2008*

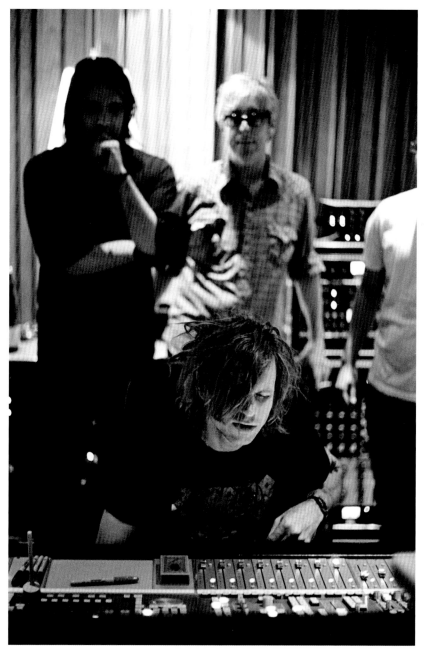

Listening to the playback of "Cobwebs" on the first day of the Cardinology *sessions, Electric Lady Studios, New York, 2008*

"The thing I love about your band is that you play every kind of music all at the same time." A fan said this to me after a gig somewhere and I thought, cool, they're getting it. I don't recall any conversation where we made a decision to make Cardinal-style an amalgam of all these disparate American musical styles. The whole idea is a bit audacious. It was just so obvious that it was happening on its own, so why talk about it?

Collectively, we have many common musical touchstones, but each of us has musical passions that aren't necessarily shared. We play American music. The magic element, and I think the strength of the Cardinals, is that we respect these different styles and tastes, embrace them, and weave them into what we do. —Jon Graboff

The music has always had a very natural flow. We have our own individual influences, but also share a lot of the same. It's very rare that as a group we try to go for a particular sound. It's all of our different choices that give us our sound. —Chris Feinstein

I think we had an idea of what we wanted our sound to be, but it evolved into something that none of us could have predicted. We all love so many different styles of music—classic rock, reggae, punk, classic country, metal, soul, you name it—consequently, our songs get filtered through all of these styles and this weird hybrid comes out the other end. I don't even know what you would call our sound, but I know it's good. Sometimes, being in the middle of it, it's difficult to have perspective on our sound, but I see how the audience reacts. We have fans of all ages. Some are just kids in junior high, some are music fans who lived through the heyday of the sixties and seventies, and everything in between, but somehow they all come together under this umbrella of the Cardinals. I stopped questioning it years ago, but I count my blessings daily that I am part of this special group of musicians who have inspired me and taught me to reach beyond what I ever thought I was capable of doing. —Brad Pemberton

Cardinology sessions, Electric Lady Studios, New York, 2008

Ryan and Tom Schick, a major figure in the Cardinals' story, whose track record speaks for itself. Tom produced and engineered *Cardinology*, *Cold Roses*, and *Jacksonville City Nights*. As a producer, he goes for a raw, natural sound and got the best live performances from the band without having to say a word. —Neal Casal

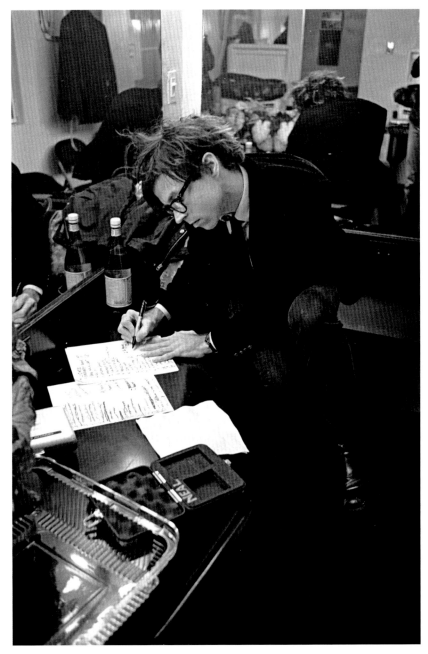

Apollo Theater, New York, 2008

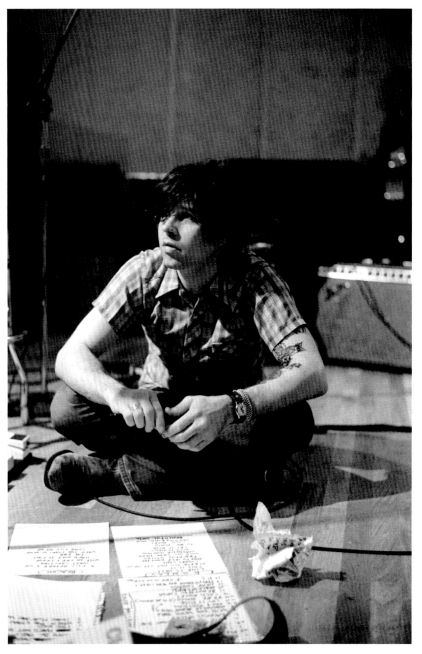

Rehearsals for summer tour, New York, 2006

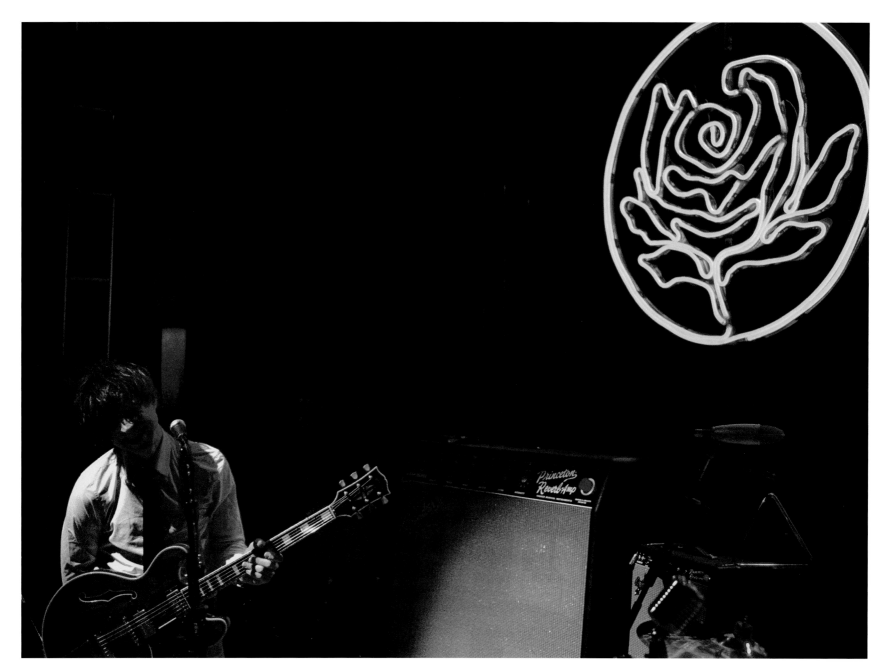

Edinburgh, 2008

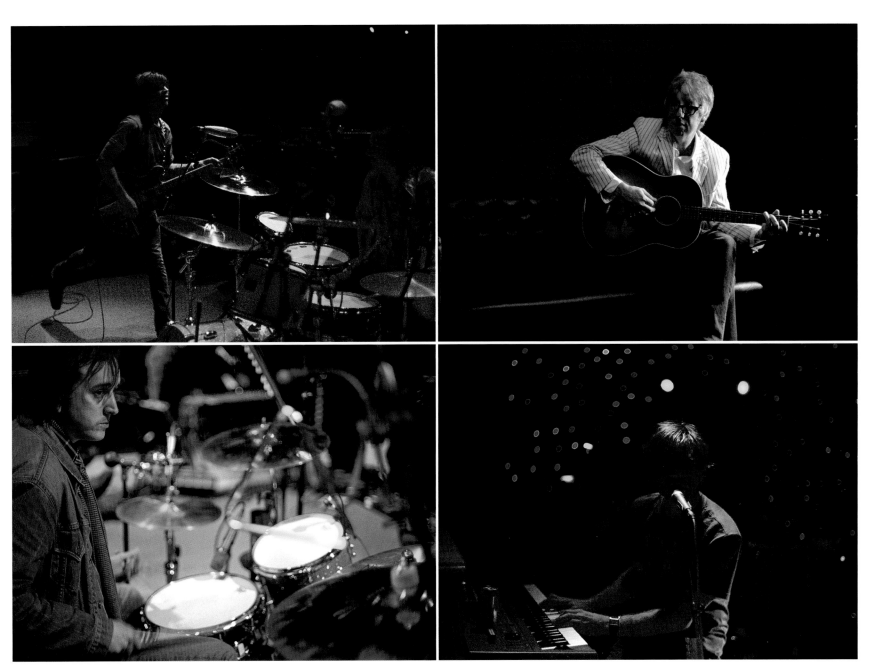

(Top left) Kansas City, 2007; (Top right) London, 2007; (Bottom left) Madison, Wisconsin, 2008; (Bottom right) Kansas City, 2007

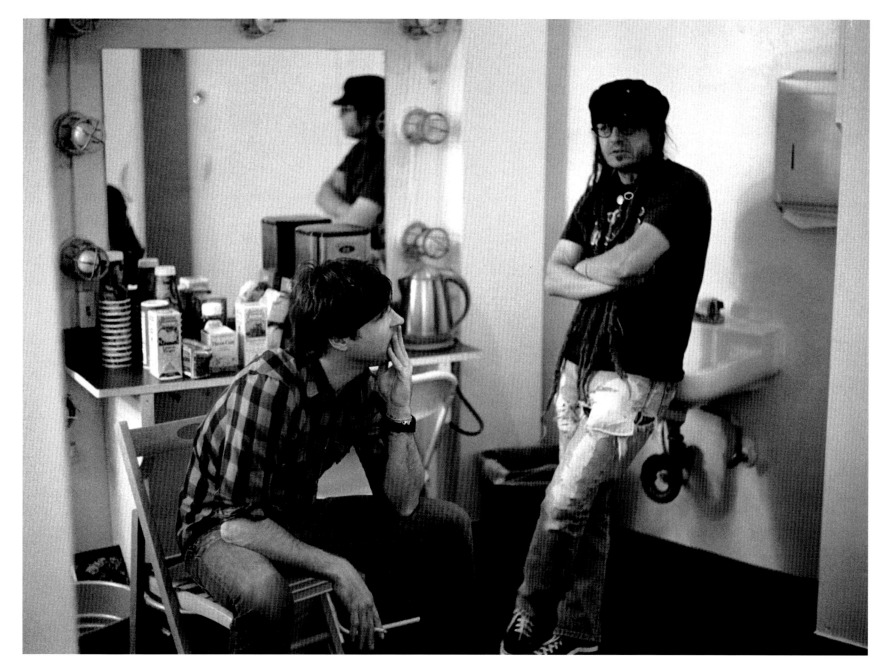

Ryan and Keith Morris, Los Angeles, 2007

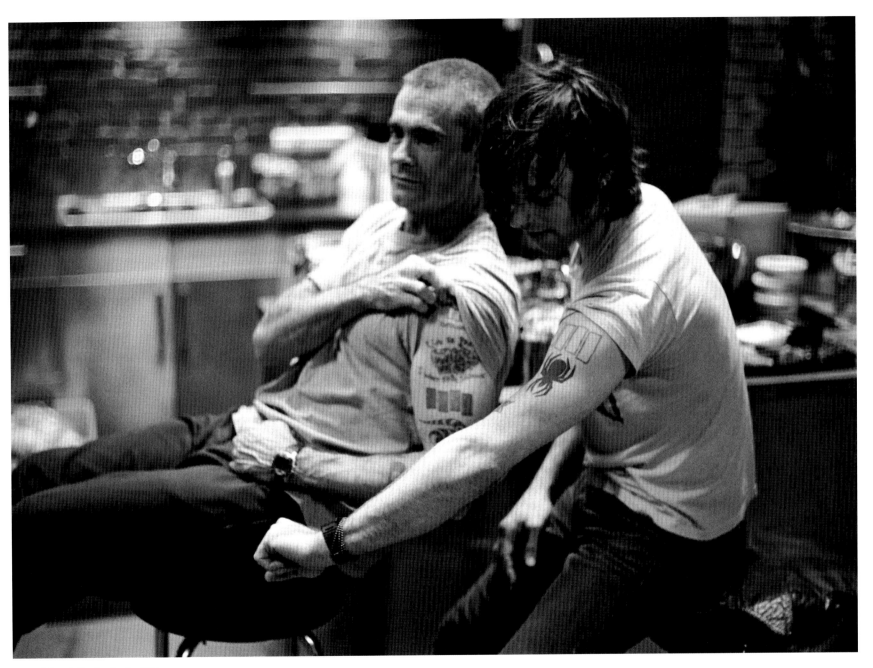

Ryan and Henry Rollins, Los Angeles, 2006

Electric Lady Studios, New York, 2006

London, 2008

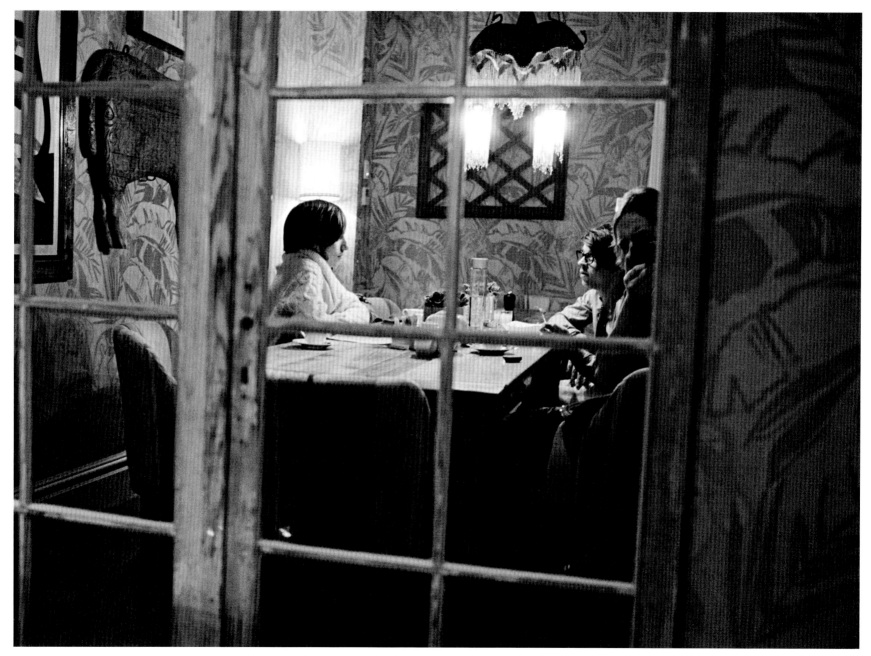

Cardinology *press tour, London, 2008*

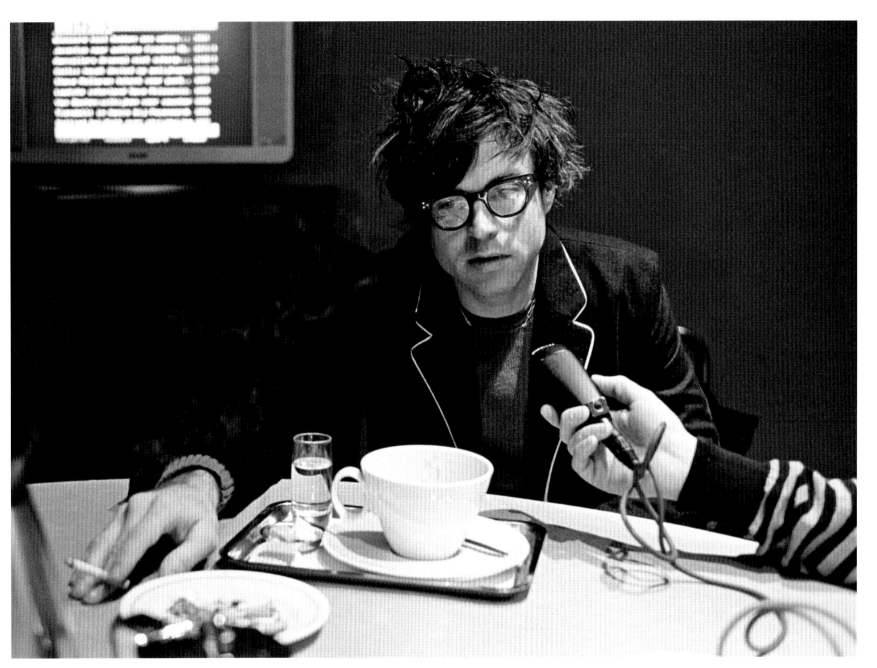

Cardinology press tour, Amsterdam, 2008

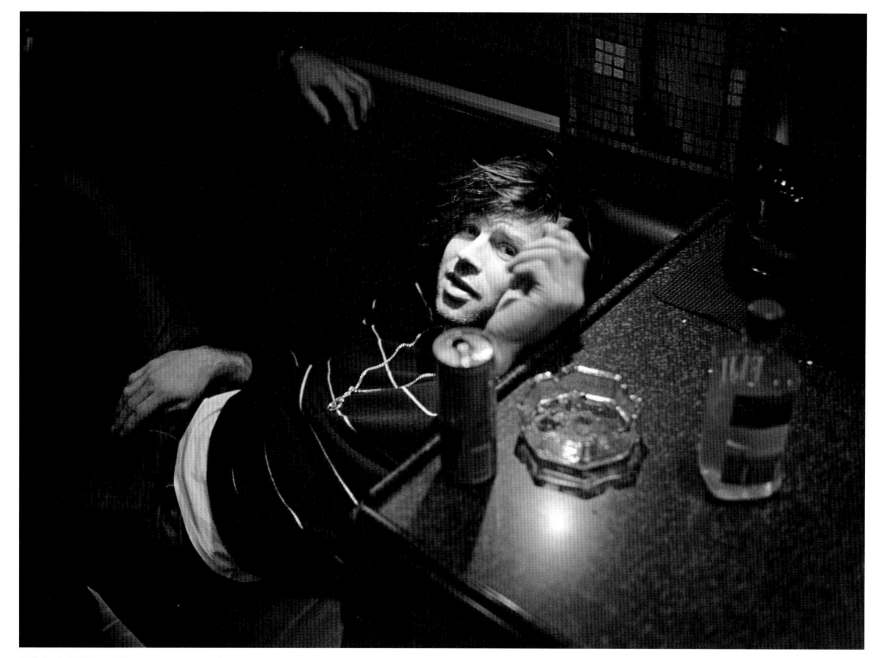

On the bus in the Midwest, 2008

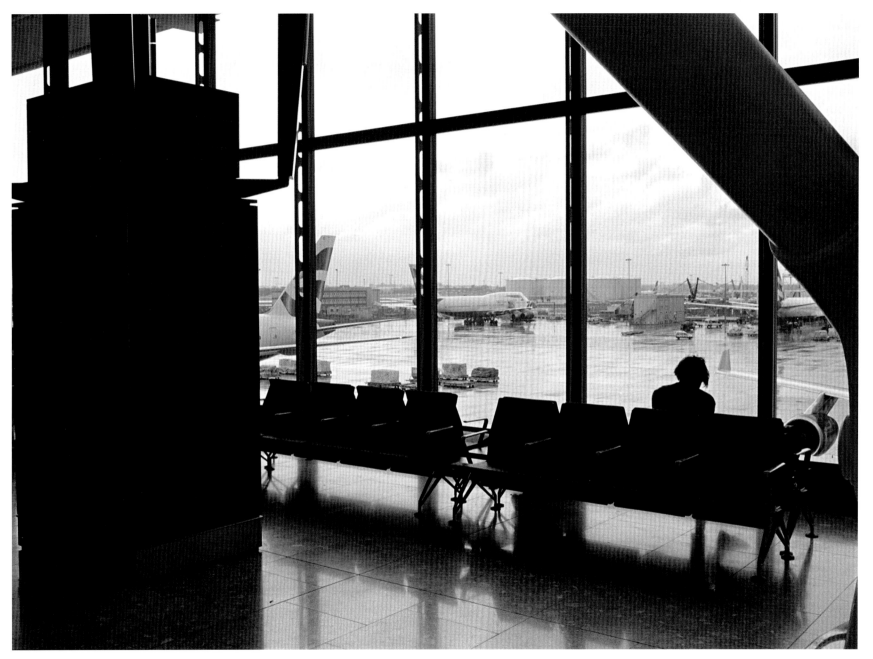

London, 2008

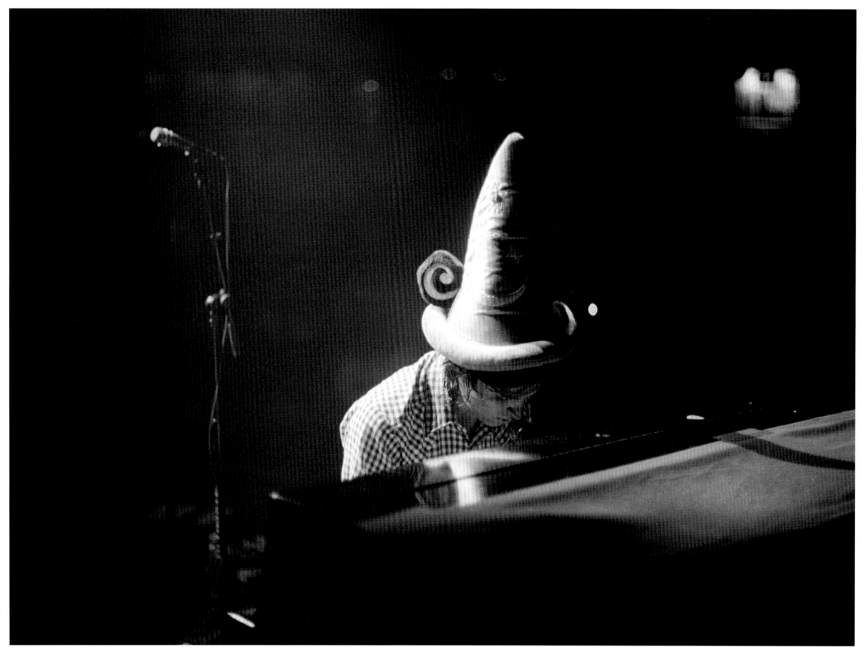

San Diego, 2006

This is the photo that affects me the most, for many reasons. It was my first show as a Cardinal and my first time back on stage in seven years. I was scared to death. That night, Ryan was being very playful with me, probably because he could sense my nerves. At some point, he ended up on the floor at my feet, playing and laughing his ass off. Then, as he went to stand back up, his head and the headstock of my bass collided—hard. He went back to the mic to sing and I noticed a stream of blood trailing down the side of his neck. Oh, fuck. Yep, first show and I split Ryan Adams's head open. I felt terrible. He felt woozy. Robie, our stage lord, brought out a towel to stop the bleeding and the wizard hat to hold it in place. Like the badass and true wizard that he is, he continued the show as if nothing had happened. And, as I sit writing this, I feel guilty to this day. Sorry, Ryan. –Chris Feinstein

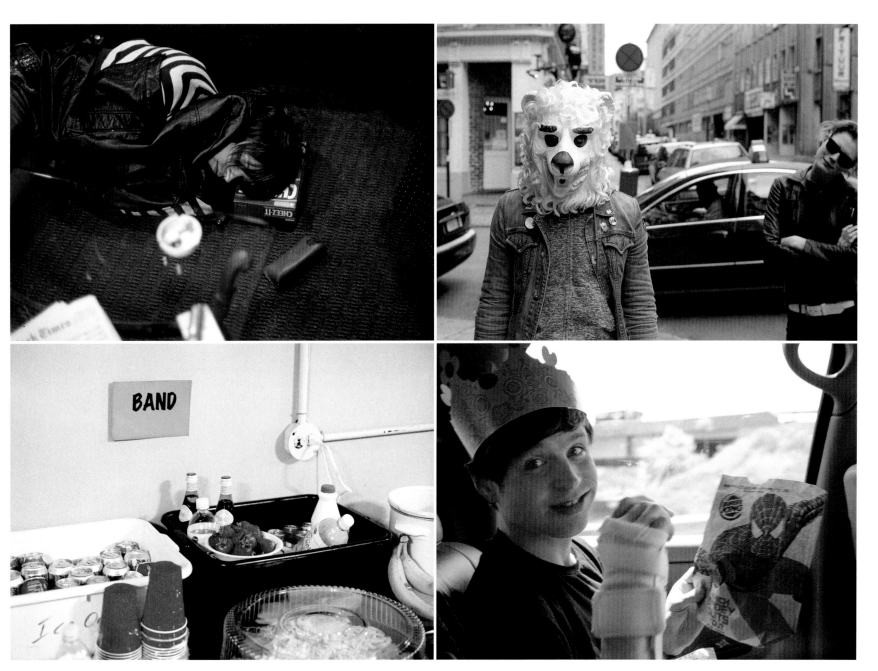

(Top left) Royce Hall, Los Angeles, 2008; (Top right) Brussels, 2006; (Bottom left) Cleveland, 2008; (Bottom right) New Jersey Turnpike, 2007

81

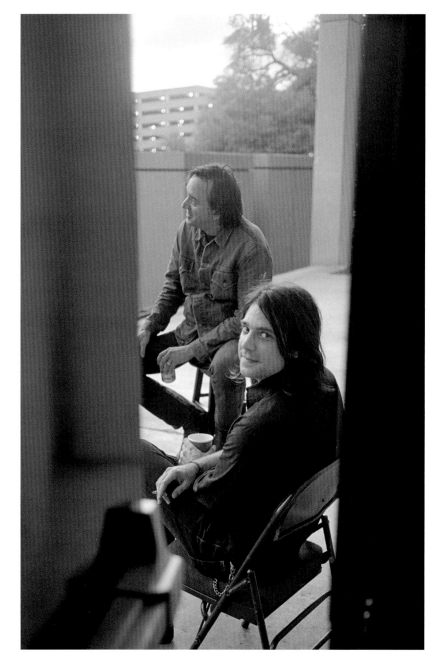

Houston, 2008

Refuge comes in many forms on the road, and you gotta grab it when it's available. Sometimes it's getting some quiet time in your bunk or taking a walk around whatever city you're in. Since Ryan turned me on to chess some years ago, I really love a game with Jon or Chris before a show—very relaxing. Just hanging with each other when you're on the other side of the world can be quite comforting, too. You need your friends out there.

You also learn when to give each other space. Being in such close quarters for weeks on end can be hard at times, but we seem to find a good balance. I've known Chris longer than I care to remember, and been with Ryan for a long time as well, but my relationships with Neal and Jon are the newest, and I can always look to both of them for inspiration and support. Neal has one of the purest, kindest souls I've ever known, with a voice and musical talent to match, and Jon is the most knowledgable musician/ music historian/comedian I've ever known. I am proud to call them my friends. —Brad Pemberton

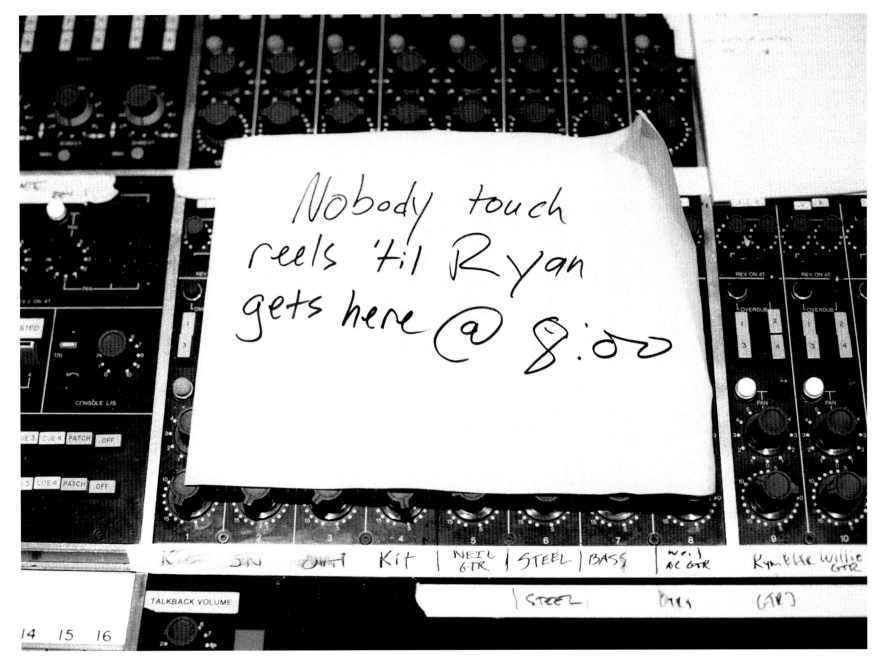

Willie Nelson Songbird sessions, Loho Studios, New York, 2005

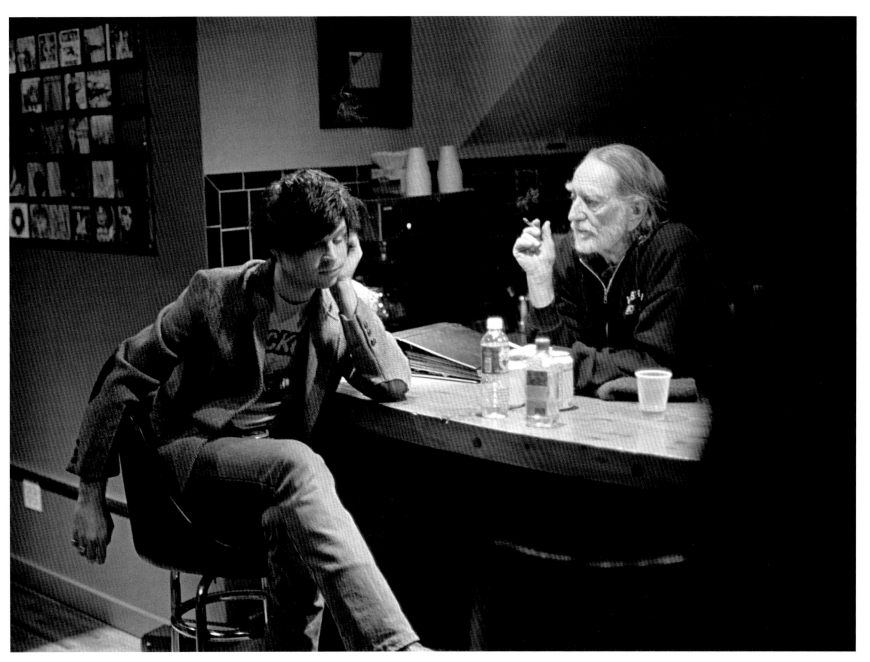

Ryan and Willie Nelson, Loho Studios, New York, 2005

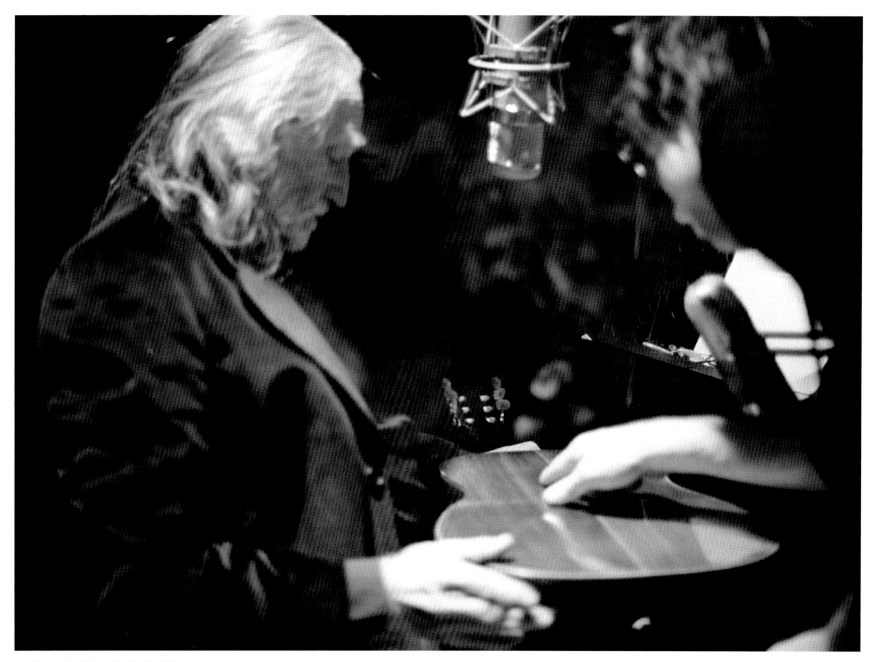

Songbird *sessions, Loho Studios, New York, 2005*

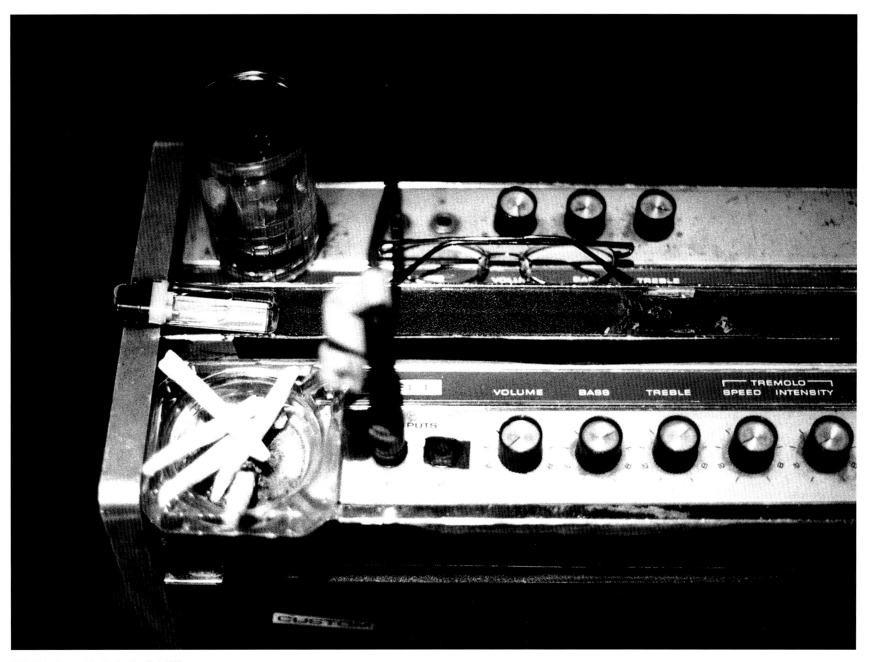

Willie Nelson's gear, Loho Studios, New York, 2005

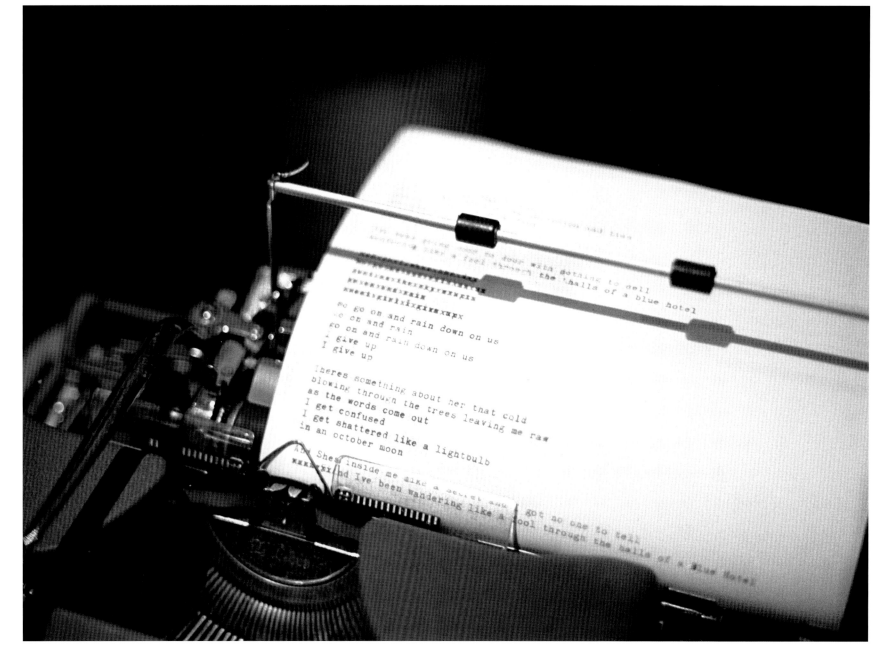

"Blue Hotel" lyrics, Songbird sessions, Loho Studios, New York, 2005

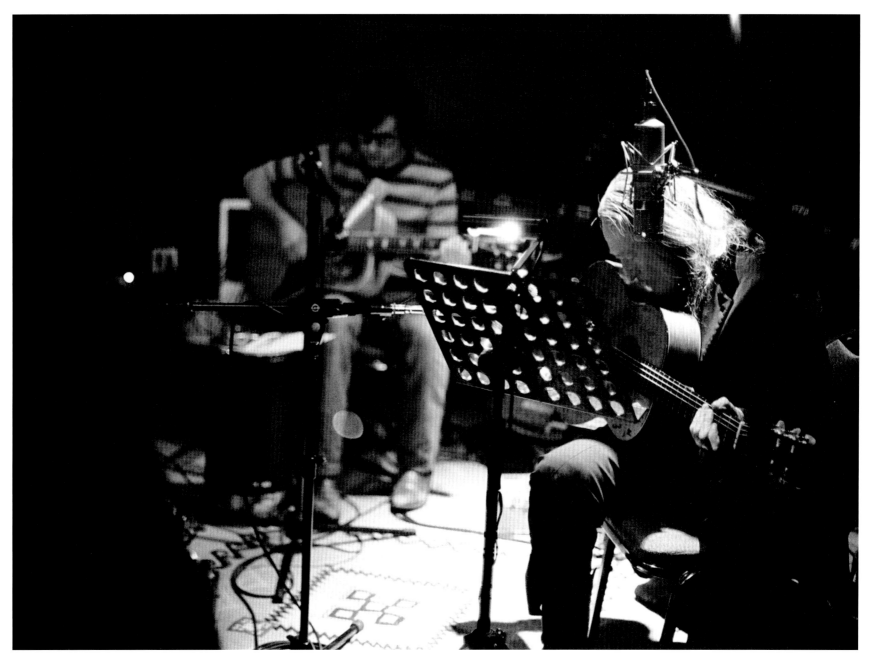

Songbird sessions, *Loho Studios, New York, 2005*

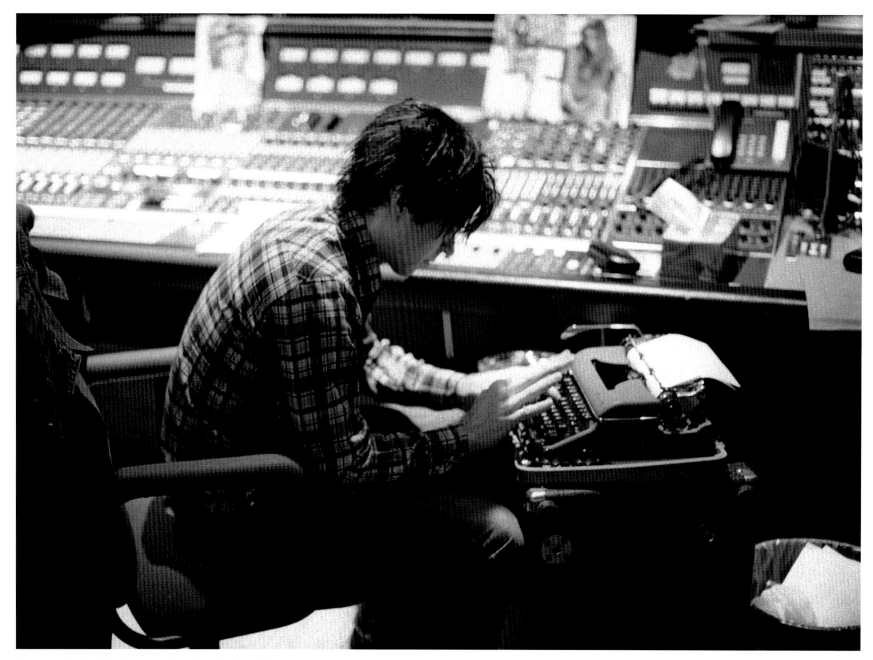

Ryan writing "Blue Hotel," Songbird *sessions, Loho Studios, New York, 2005*

It was just Ryan, Brad, and me in the control room one night, waiting for Willie to show up. Everyone else was milling around, playing pool, ordering food, setting up gear, etc. In a classic bolt of Ryan lightning, he turned to me and said, "Neal, hand me your guitar, I'm going to write a song for Willie to sing right now." He picked out a few chords, sat down at his typewriter, and wrote this classic song in about ten minutes. Willie arrived and we recorded it that night. –Neal Casal

Willie Nelson, New York, 2005

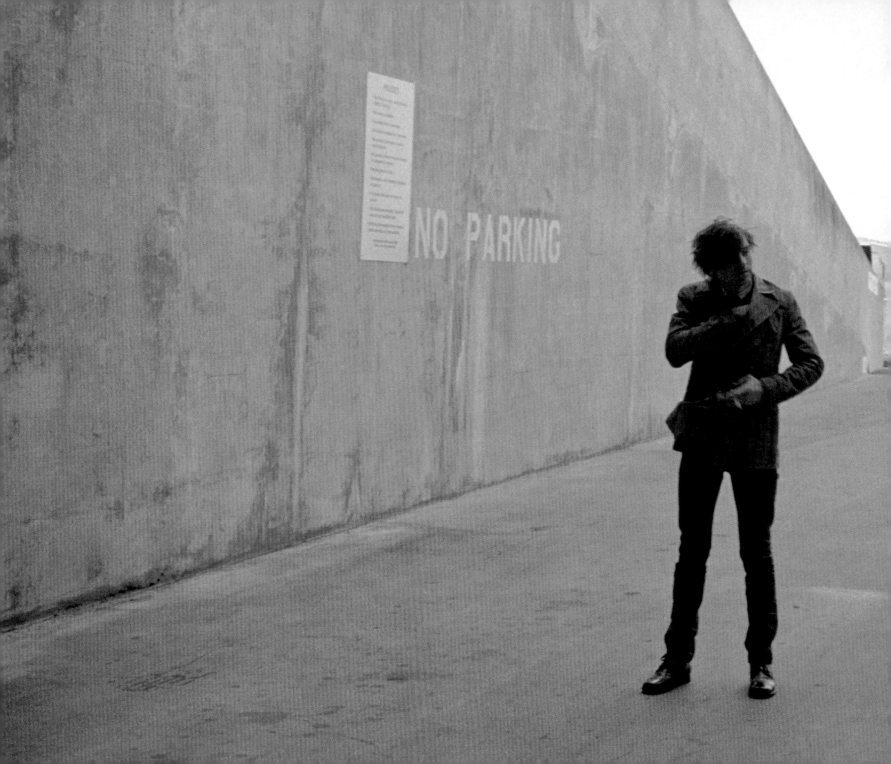

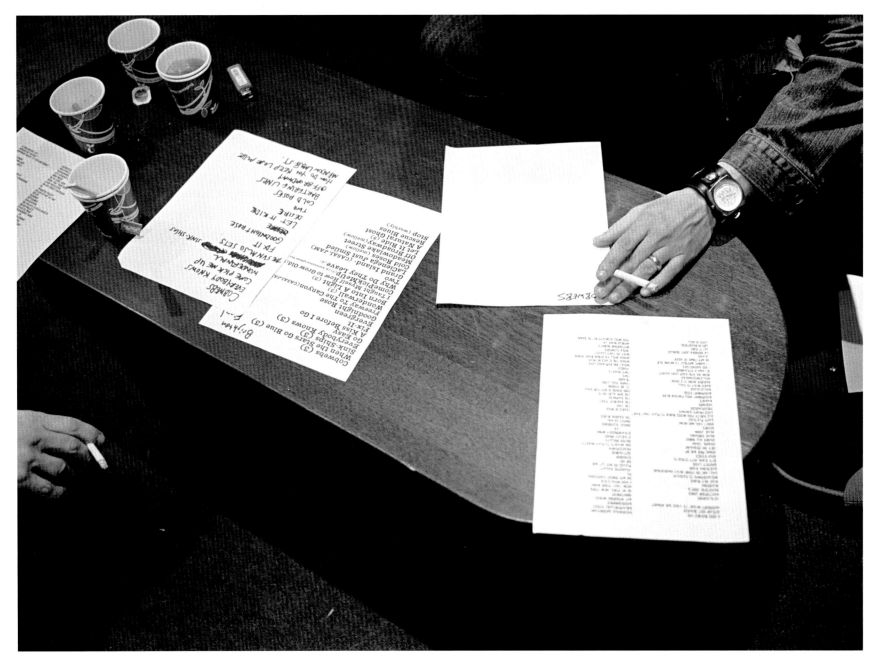

Brixton Academy, London, 2008

Previous page: Oakland, California, 2008

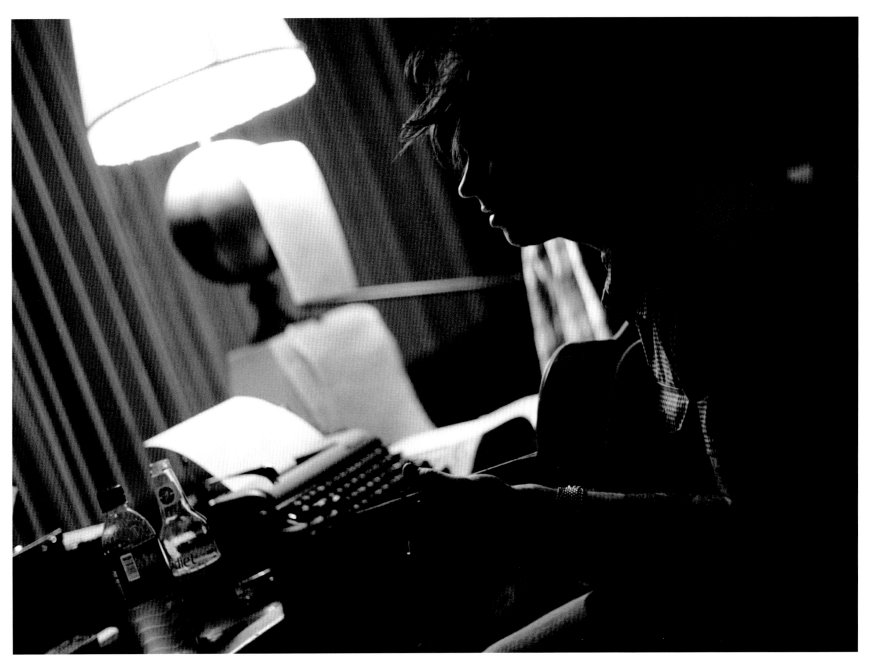

Easy Tiger *sessions, Electric Lady Studios, New York, 2006*

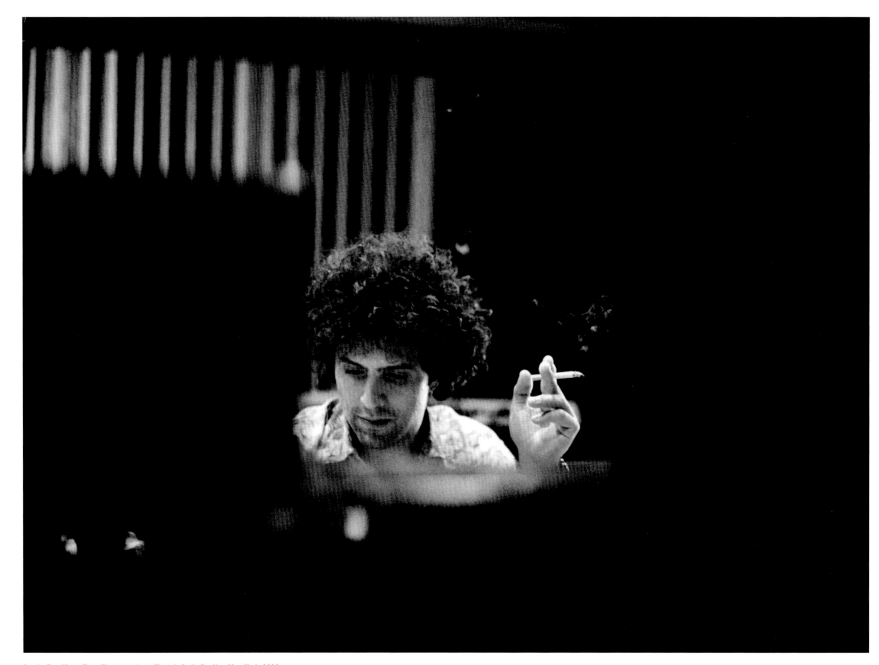

Jamie Candiloro, **Easy Tiger** *sessions, Electric Lady Studios, New York, 2006*

Jamie produced, engineered, and mixed *Easy Tiger* and *Follow the Lights*, and helped finish Willie Nelson's *Songbird* record. He's incredibly talented in all things sonic and is an outstanding musician, as well. He was on the road with us, playing piano for a large part of the *Easy Tiger* tour. –Neal Casal

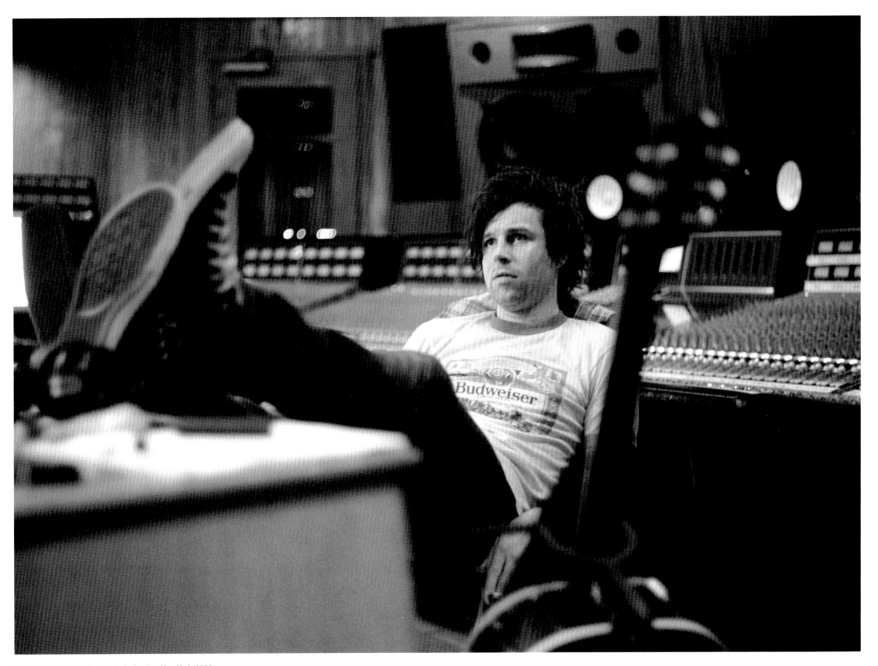

Easy Tiger *sessions, Electric Lady Studios, New York, 2006*

Chicago, 2008

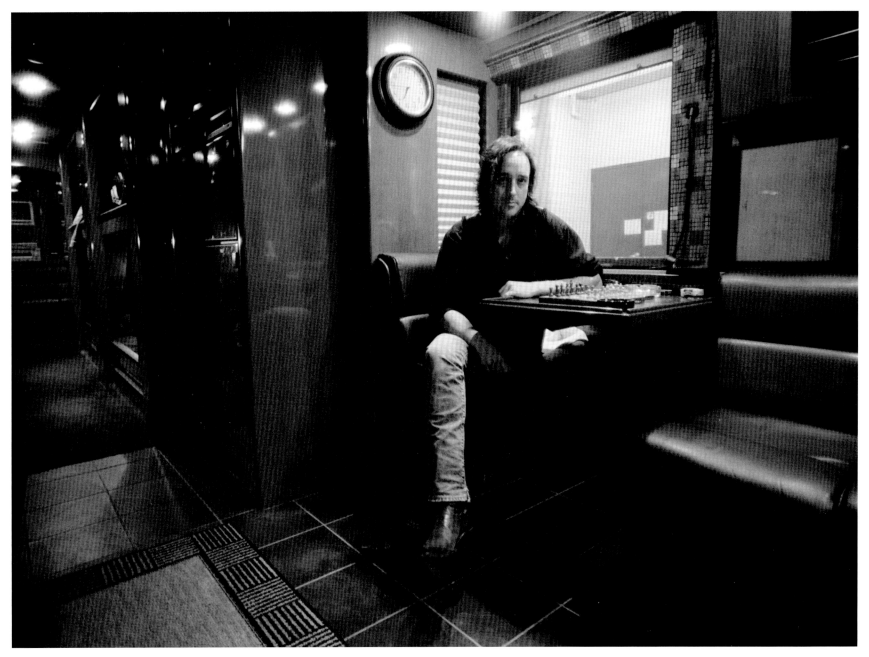

Ottawa, 2008

Waiting, and time in general, is the bane of touring musicians' lives. We basically wait all day to go play for two hours. Those other twenty-two or so hours can be the most difficult. Creatively, however, a lot of good things can come from that time. Sitting in the back of the bus while traveling, waiting in the dressing room before showtime, and especially soundchecks, have spawned many a good tune. It's all how you use your time. And aside from the creative/professional aspect, it's usually when I laugh the most, have really meaningful conversations, or just lend an ear to a bro when someone is having a rough day. –Brad Pemberton

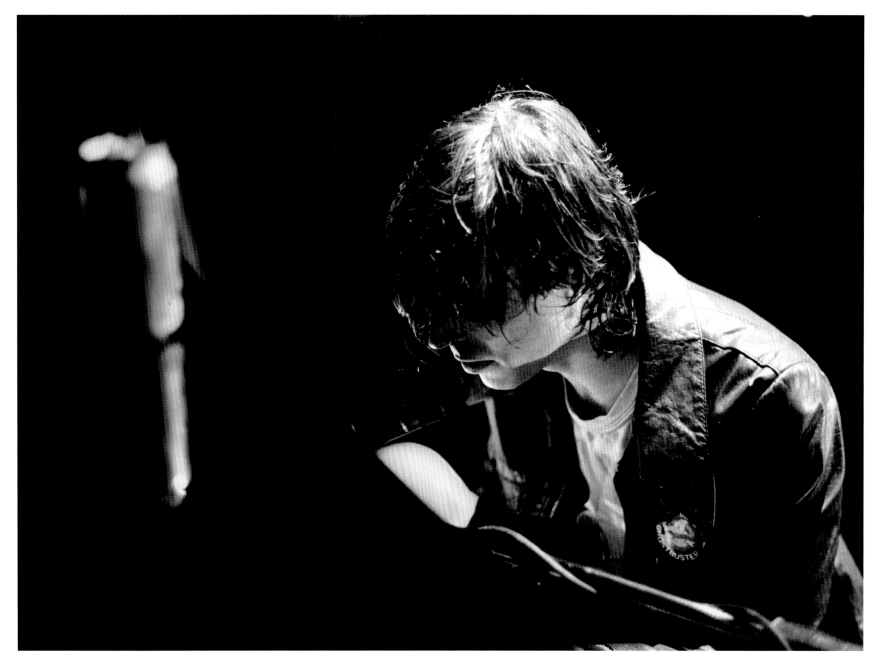

Anaheim, California, 2006

Amsterdam, 2006

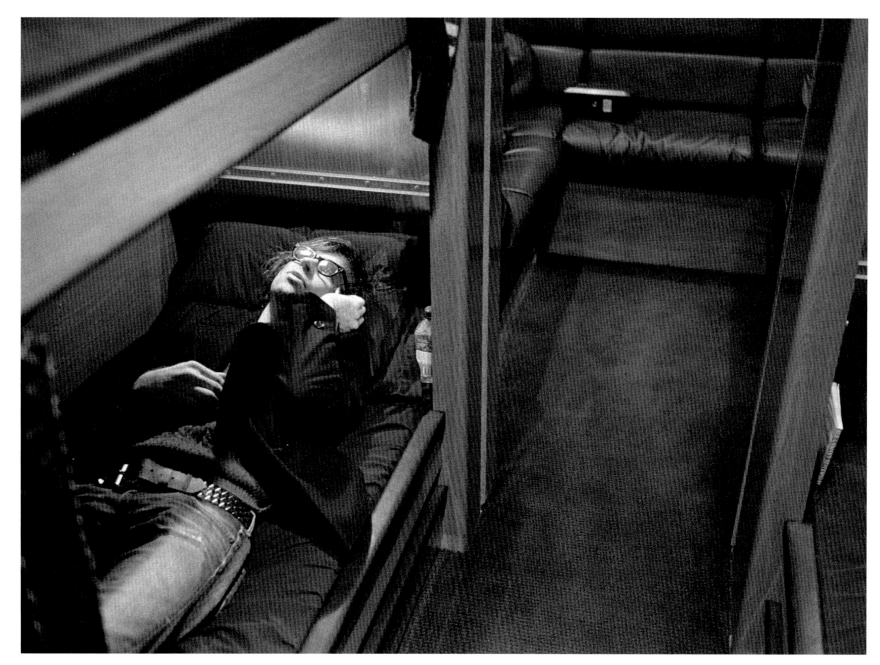

Washington, D.C., 2008

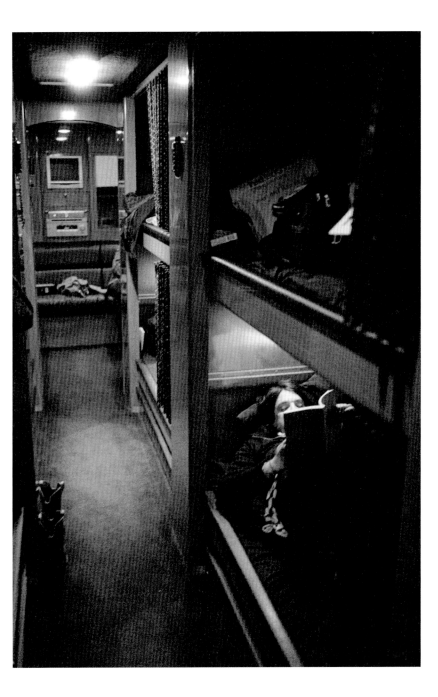

The tour bus is like a big tin can on wheels. There's not a lot of privacy to be had and you get to know your fellow inmates better than you ever thought you would. You can climb into your bunk and draw the curtain when you want to be alone, but we spend a surprising amount of time hanging out, telling stories, or playing chess. I can't say I've experienced this in other bands I've been in, but the more time we spend together, the more we seem to like each other—you can see it in these photographs. —Jon Graboff

I tend to hibernate and seek alone time on tour. That said, these guys have become my brothers— true family—and we know each other very well. The time spent together is usually spent laughing or sharing music and stories. —Chris Feinstein

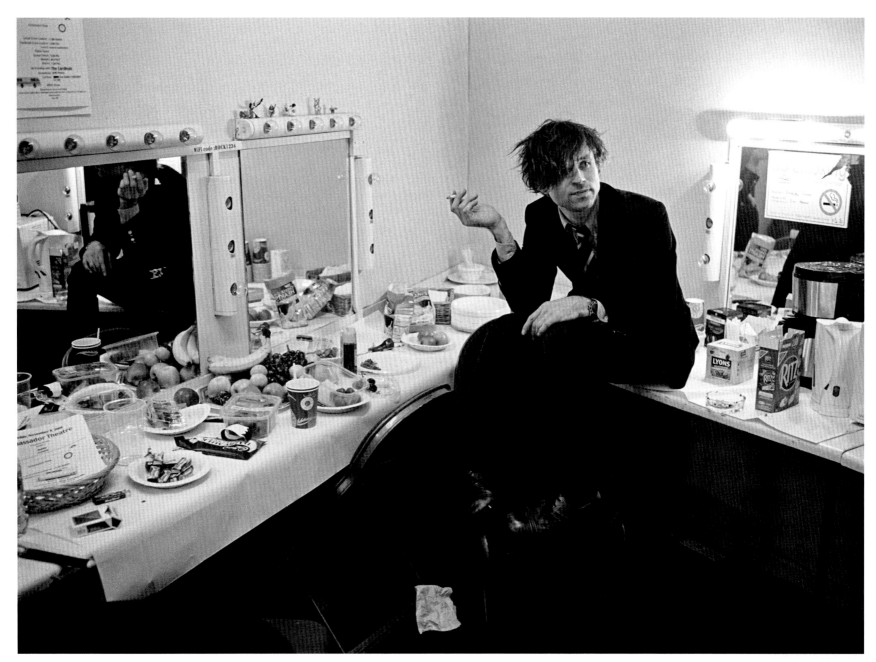

Dublin, 2008

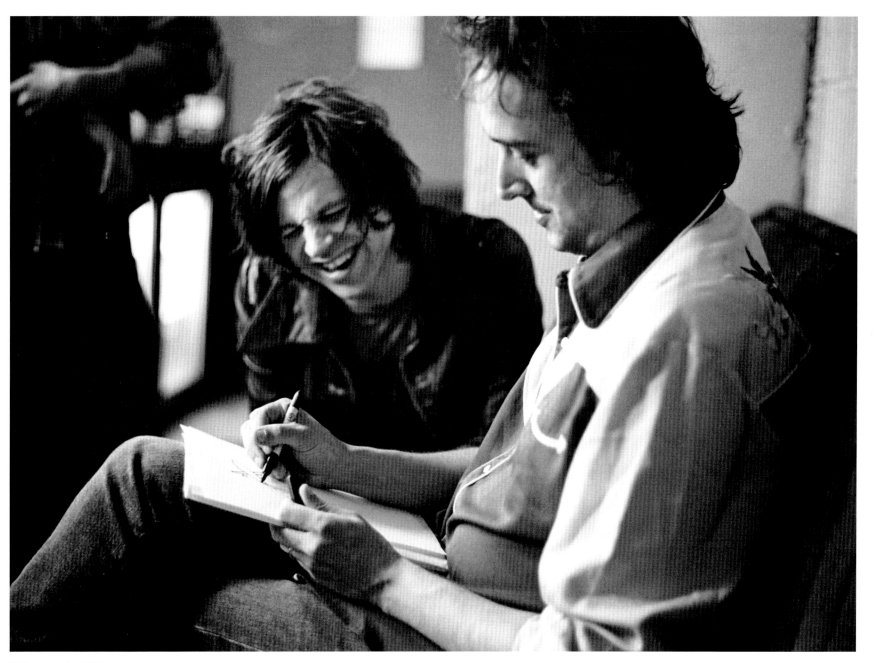

Nottingham, England, 2006

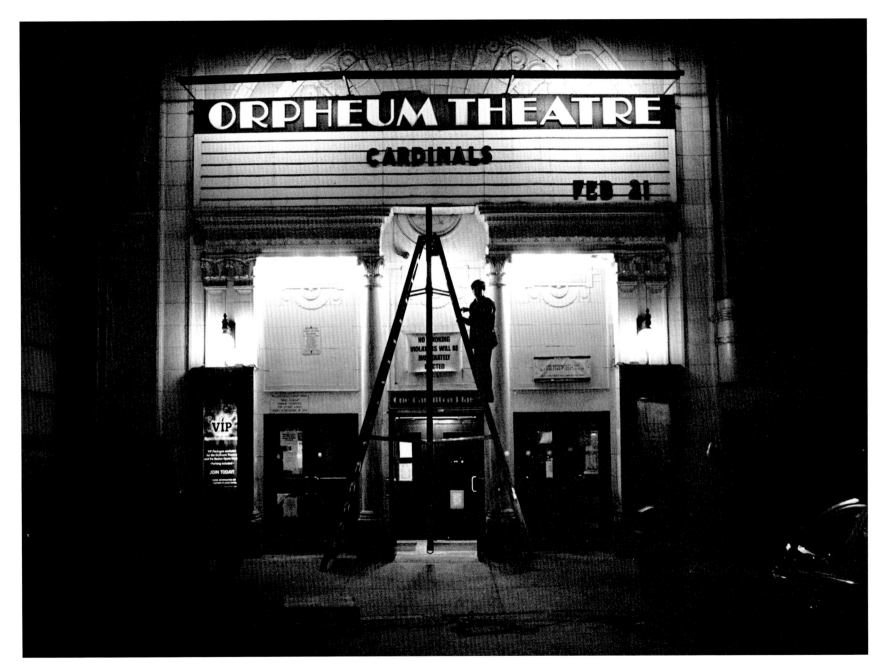

Ryan at the Orpheum Theatre, Boston, 2009

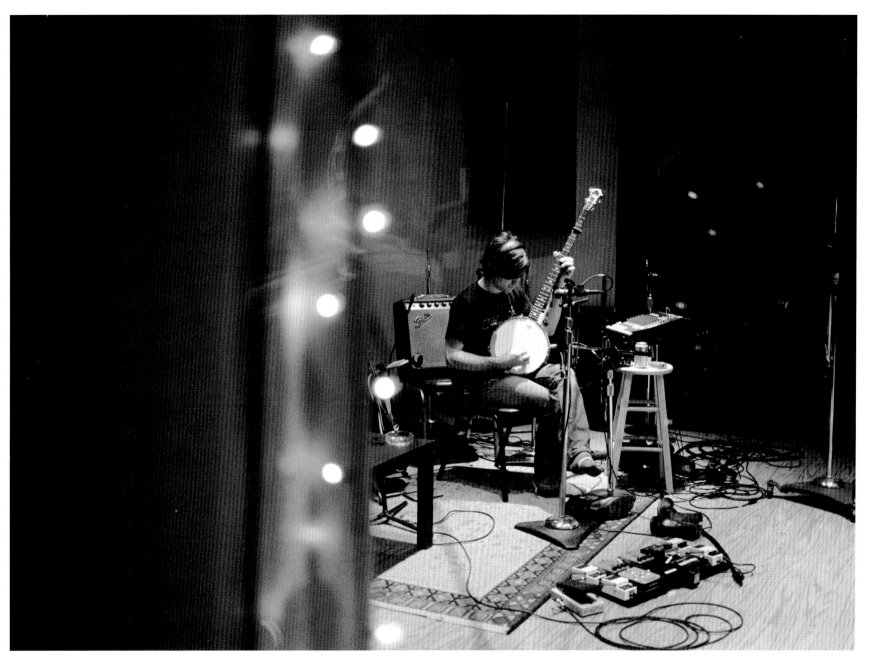

Follow the Lights *sessions, Sunset Sound Studios, Los Angeles, 2007*

Laguna Beach, California, 2003

An accidental album cover. One of my early photo experiments was renting a Leica because I had always wanted to try one. It's an awkward machine at first—I was just learning to use the focusing mechanism, randomly pointed the camera out the window, and shot this photo. It was the fourth frame on the first test roll. I had to laugh when Ryan asked to use it for the *Follow the Lights* EP cover years later. –Neal Casal

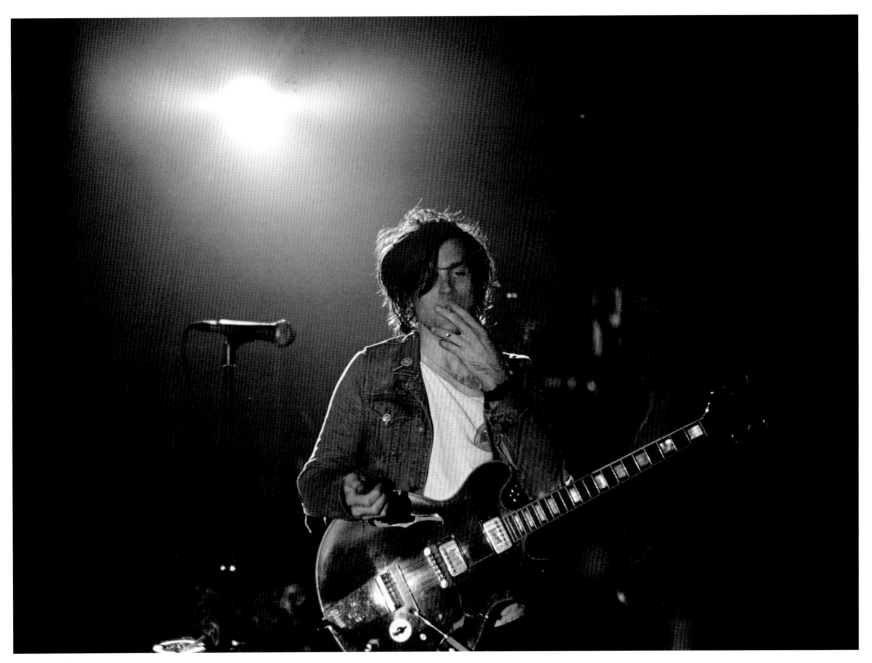

Copenhagen, 2006

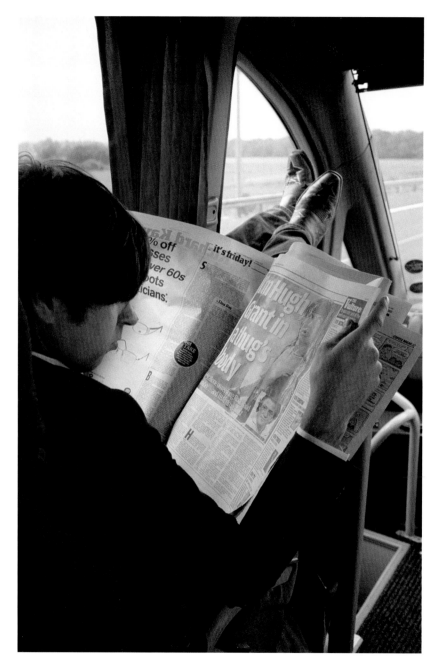

Manchester, England, 2007

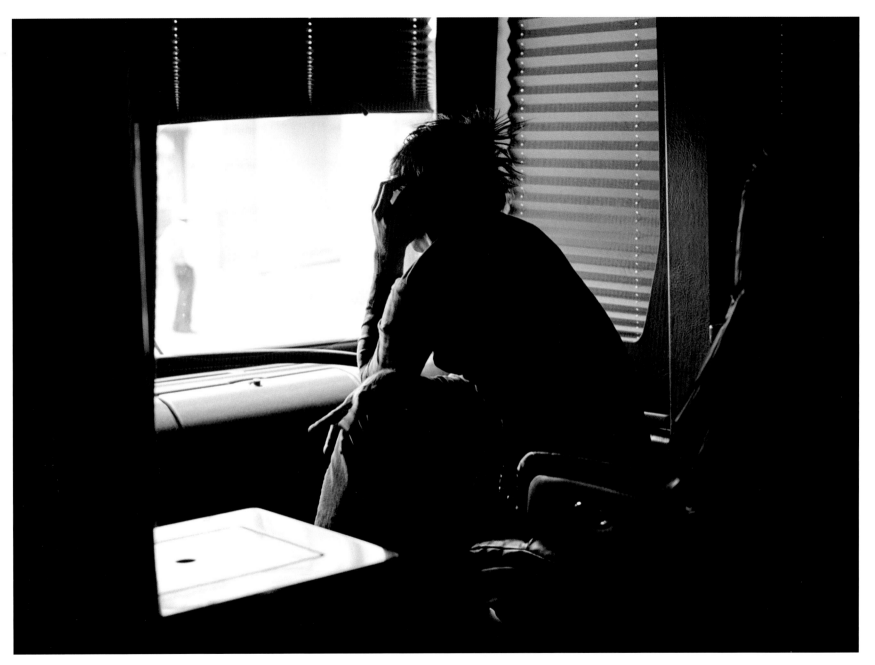

Indianapolis, 2008

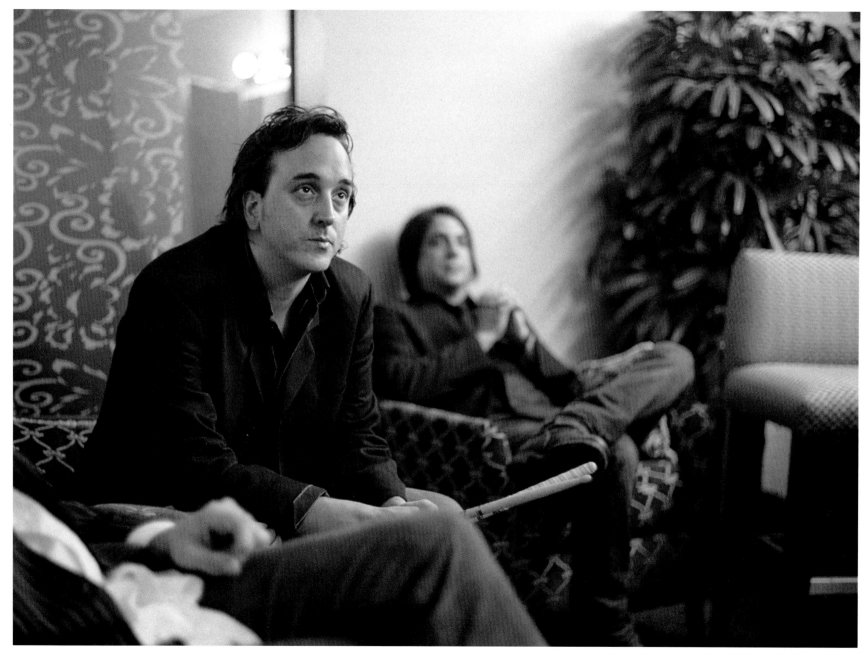

Backstage at the Tonight Show, Los Angeles, 2007

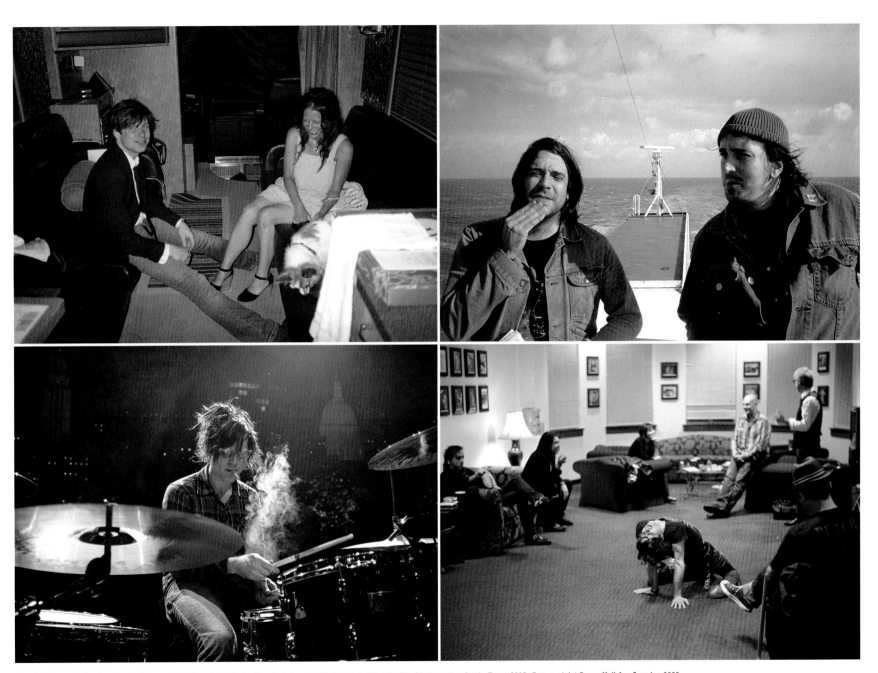

(Top left) Ryan with Amy Lombardi, Chicago, 2007; (Top right) On the ferry to Ireland, 2006; (Bottom left) Austin City Limits *taping, Austin, Texas, 2005; (Bottom right) Royce Hall, Los Angeles, 2008*

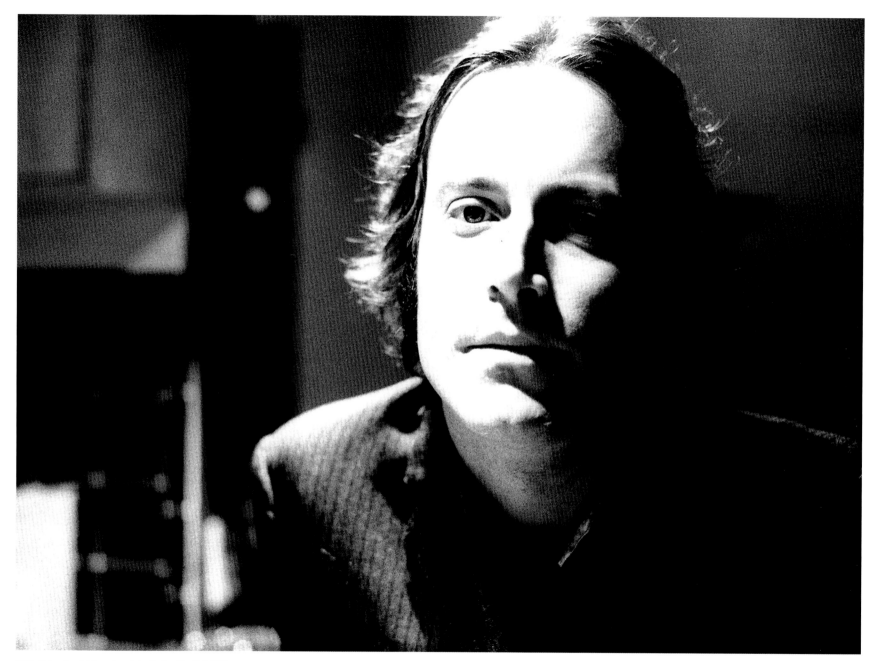

Willie Nelson Songbird *sessions, Loho Studios, New York, 2005*

There's really only one major difference in Neal's role as guitarist and as a photographer, and it's physical proximity. When he's being a musician, he's right in the thick of it, but when he grabs his camera, he steps back and away. Yet he always evokes the same keen sense of what's going on at that moment, which is critical in both roles. —Jon Graboff

There is not much of a difference between Neal, the guitar player, and Neal, the photographer. Neal has a very sensitive eye for detail and the same can be said for his beautiful musicianship. I am as comfortable on stage playing with him as I am when he's shooting a picture. He has my total and absolute trust. —Chris Feinstein

Neal is almost invisible as a photographer. You never notice he is taking a photo until you hear the click of the shutter. But as a guitarist and singer, you notice him right away. His classic, tasteful playing and beautiful voice are hard to miss. But I think where the similarity lies is in the physical: his eyes for his photos and his ears for his music. His approach to both is quite thoughtful. He seems to know exactly when and where to take the shot and he never interferes with it. An organic approach. No one else could ever get inside of us the way he does. —Brad Pemberton

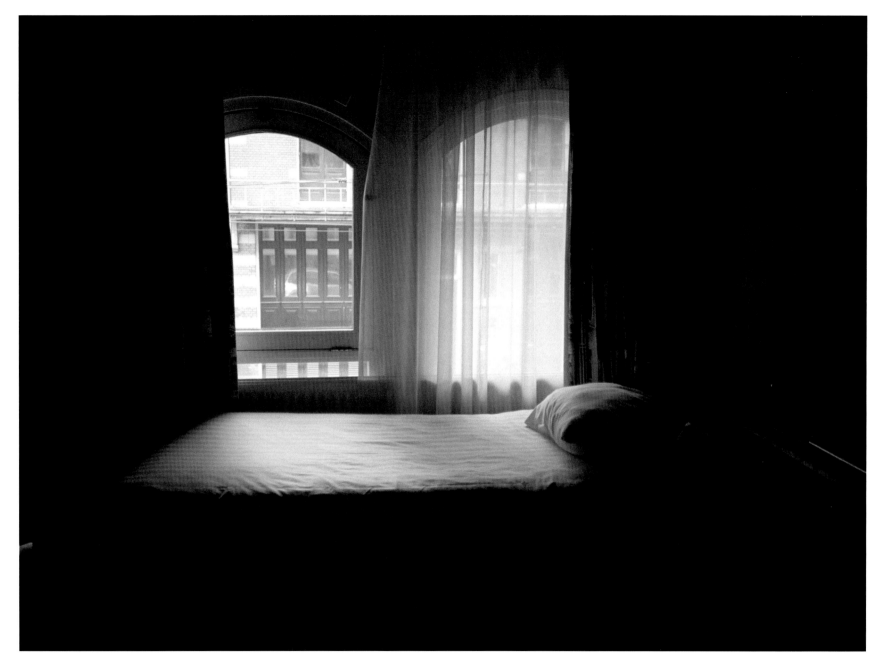

Amsterdam, 2006

St. Louis, 2008

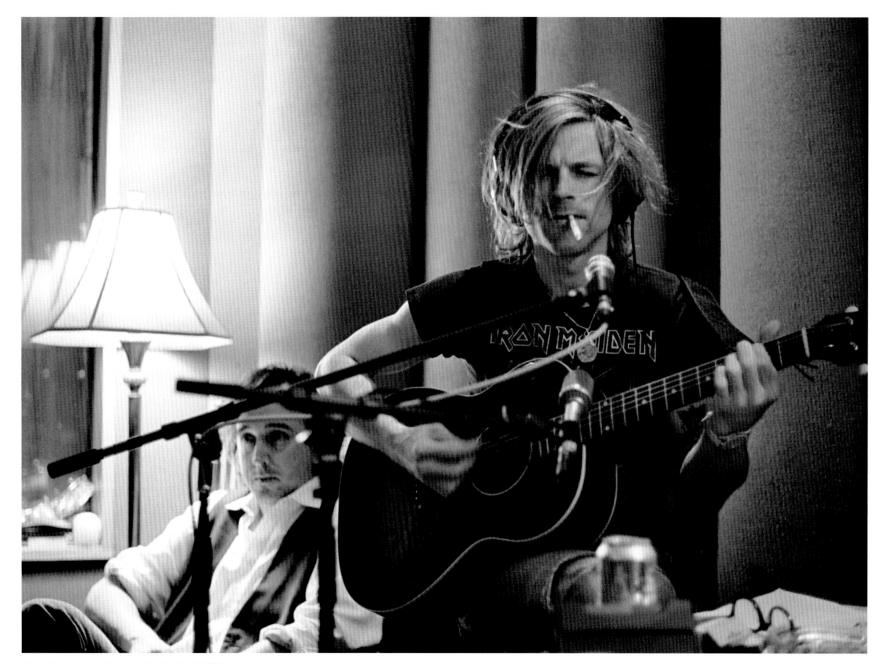

Cardinology sessions, Electric Lady Studios, New York, 2008

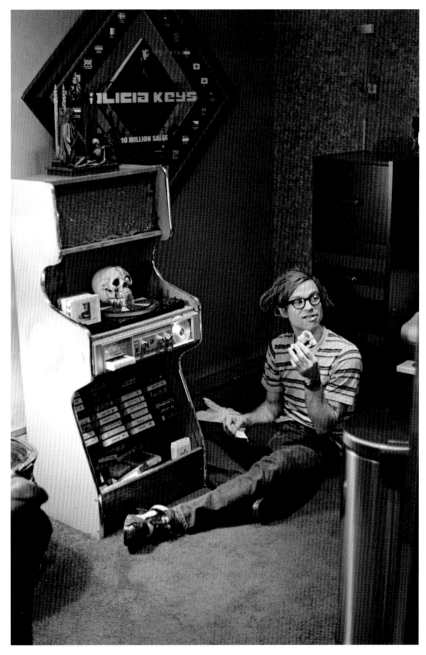

Electric Lady Studios, New York, 2008

New York, 2005

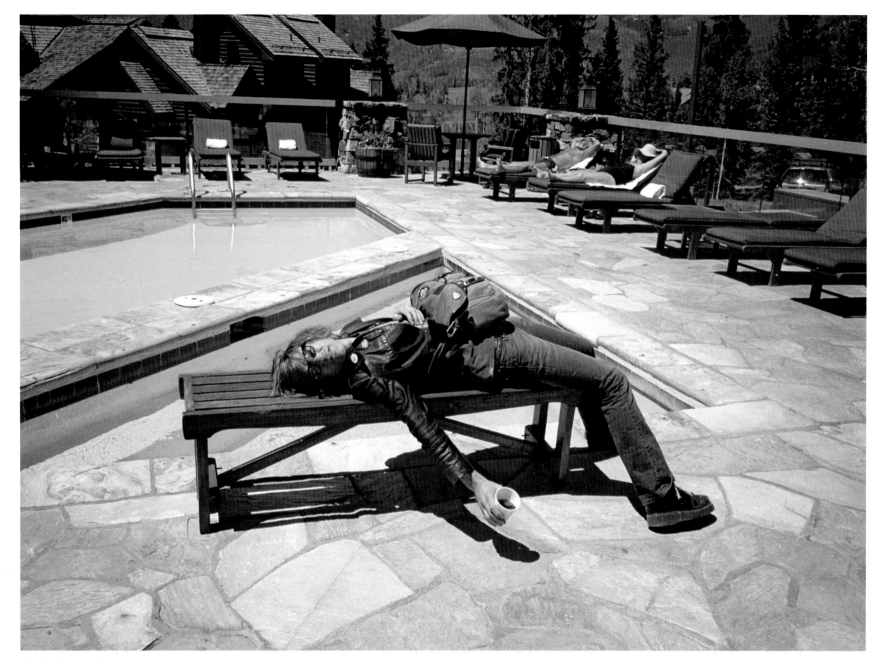

Telluride, Colorado, 2008

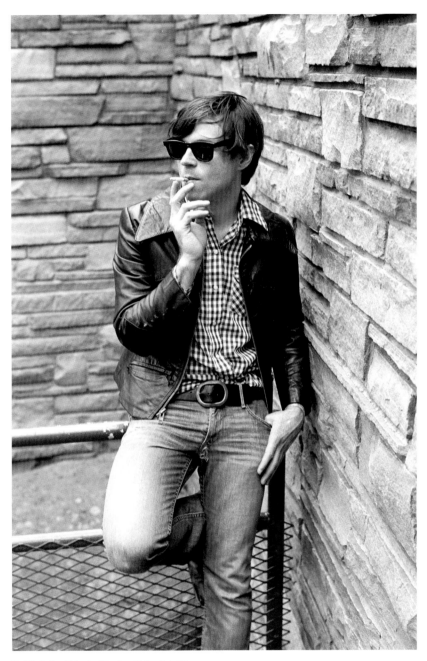

Red Rocks Amphitheatre, Morrison, Colorado, 2007

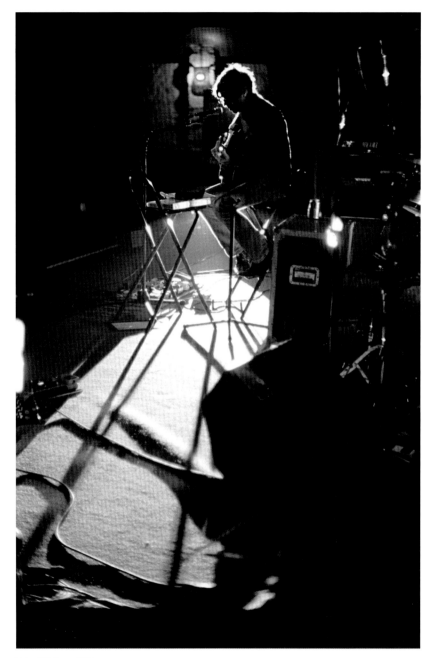

Tulsa, Oklahoma, 2008

One of the revelations many may have when looking at these photographs is seeing the similarity between the public and private personas of the band members. Neal's photographs of me tend to reveal a person slightly on the outside, yet engaged and observant. I like to think of the pedal steel guitar as a responder: at times commenting on the emotional heart of the song, and at other times singing along. —Jon Graboff

Neal has captured every aspect of my personality and how my mood changes, pre-show to post-show. Somehow I never even know he's taking pictures. —Chris Feinstein

I'm a fairly private person, and have never liked having my photo taken, but Neal was able to snag shots that even I love. I tend to always have my guard up, maybe a bit more than the other guys, but Neal has been able to take a peek behind my exterior and get some truly amazing shots. And it didn't take very long for Neal to gain my trust. Maybe it was because of our musical connection, but we crossed over into the photographer/subject world pretty easily. I think Neal and I are more alike than either one of us realizes or maybe cares to admit. We express our feelings and emotions a bit differently, but we seem to always end up on the same page at the end of the day. There are people I've known much longer who I don't have that connection with. —Brad Pemberton

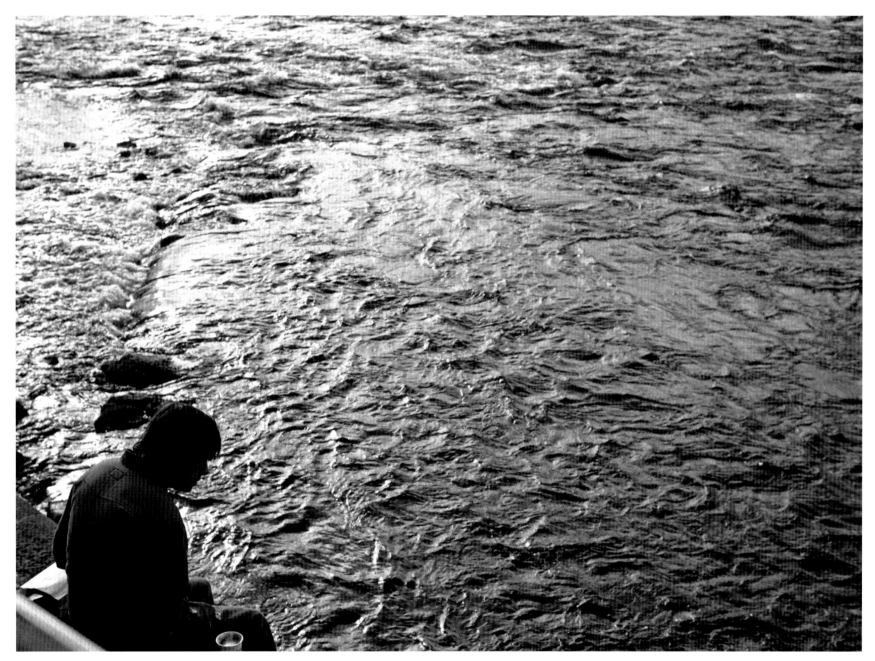

Galway, Ireland, 2006

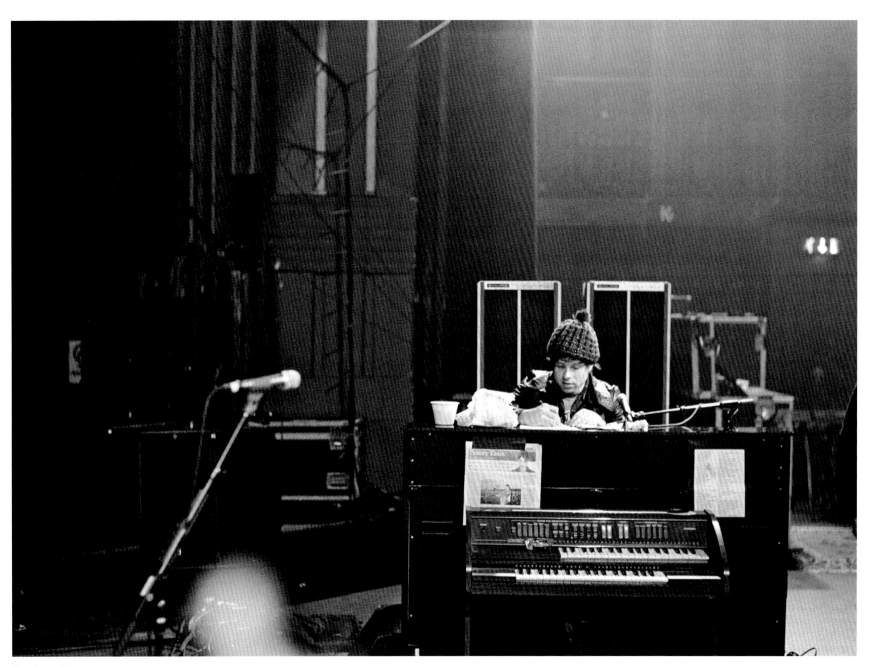

Copenhagen, 2007

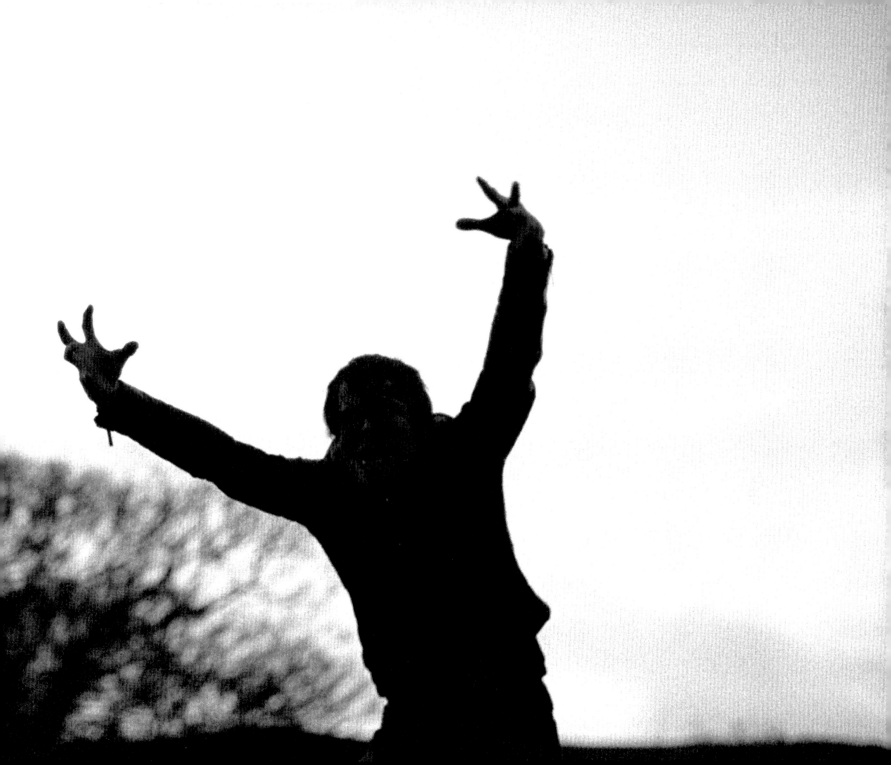

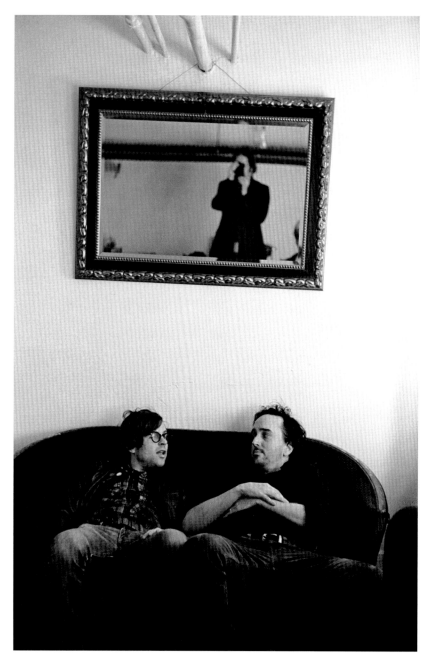

Santa Barbara, California, 2008

Previous page: Dingle, Ireland, 2007

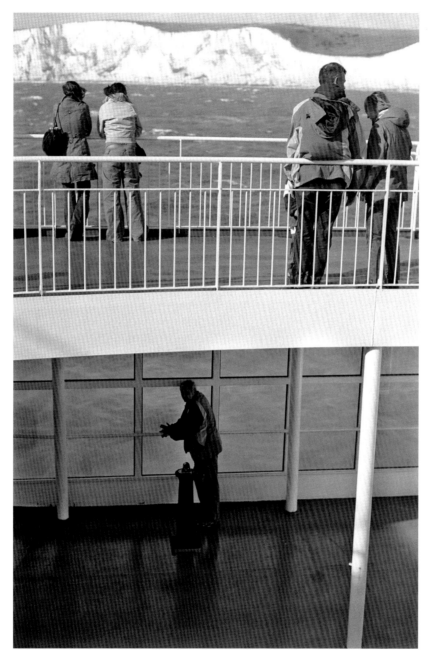

Ferry from Ireland to England, 2006

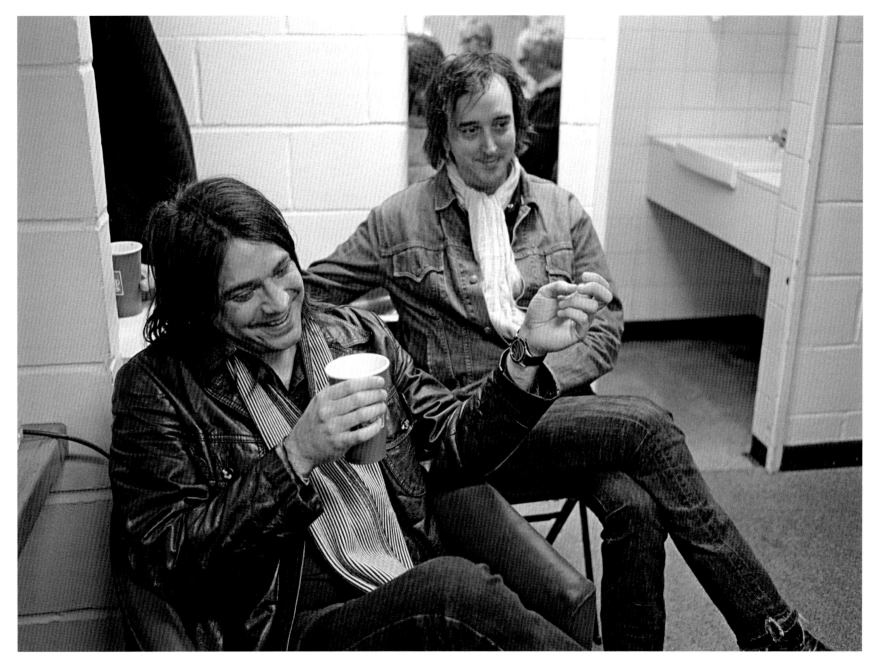

Cambridge, England, 2008

Brad and I have known each other since we were teenagers. We loved the same music and eventually ended up in a band together through most of the nineties. I think our take on being the rhythm section has always been to sit back and support. We look to lay a foundation for the interplay of three guitars and the subject matter of the song. –Chris Feinstein

I've known Chris and his family for so long I'm an honorary Feinstein. A good friend of ours said we share the same heartbeat. Twenty-plus years of friendship has made us mind readers. We often crack each other up on stage because we'll play some rhythm pattern we've never played before at the same time—total ESP. Providing a solid floor for Ryan, Neal, and Jon to dance on is our job, but we manage to pick our moments to shine, too. Being able to make an entire audience move to your pulse is a powerful thing. Chris is also one of the funniest people I've ever known, and there is never a shortage of laughs when he is in the room. –Brad Pemberton

Somewhere in the Midwest, 2008

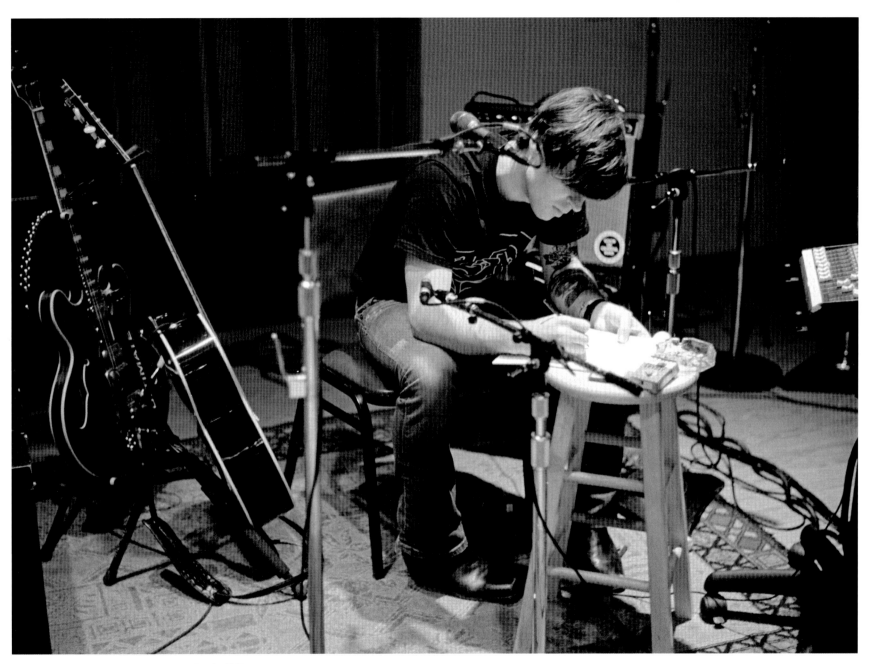

Follow the Lights *sessions, Sunset Sound Studios, Los Angeles, 2007*

Dublin, 2008

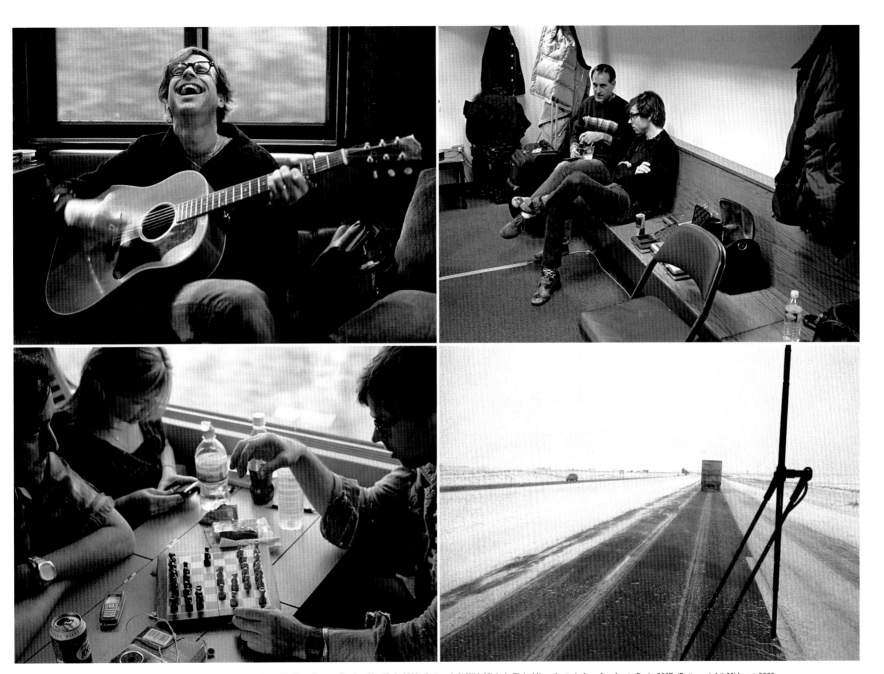

(Top left) Driving through the Midwest, 2008; (Top right) Ryan with John Silva, Madison Square Garden, New York, 2008; (Bottom left) With Michele Fleischli on the train from London to Paris, 2007; (Bottom right) Midwest, 2008

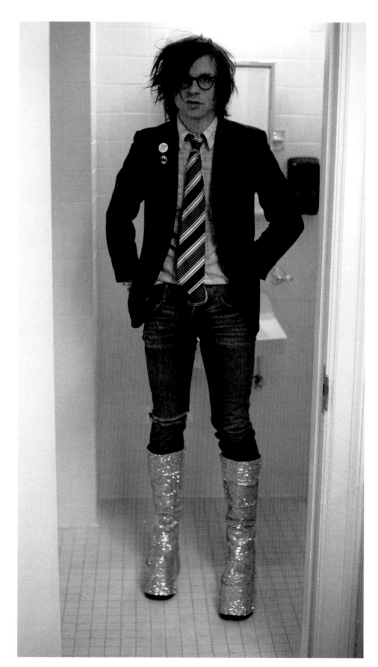

Town Hall, New York, 2006

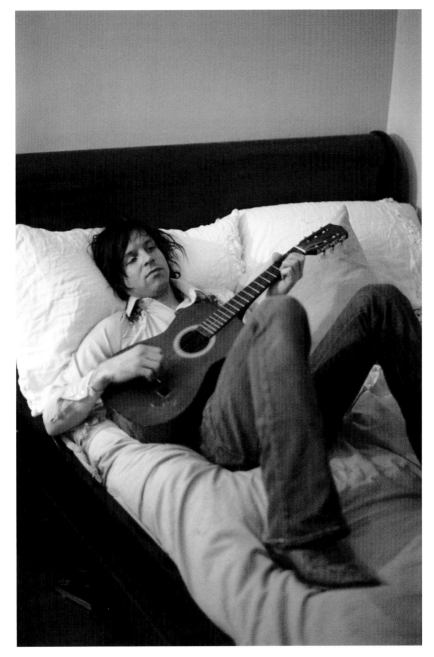

New York, 2005

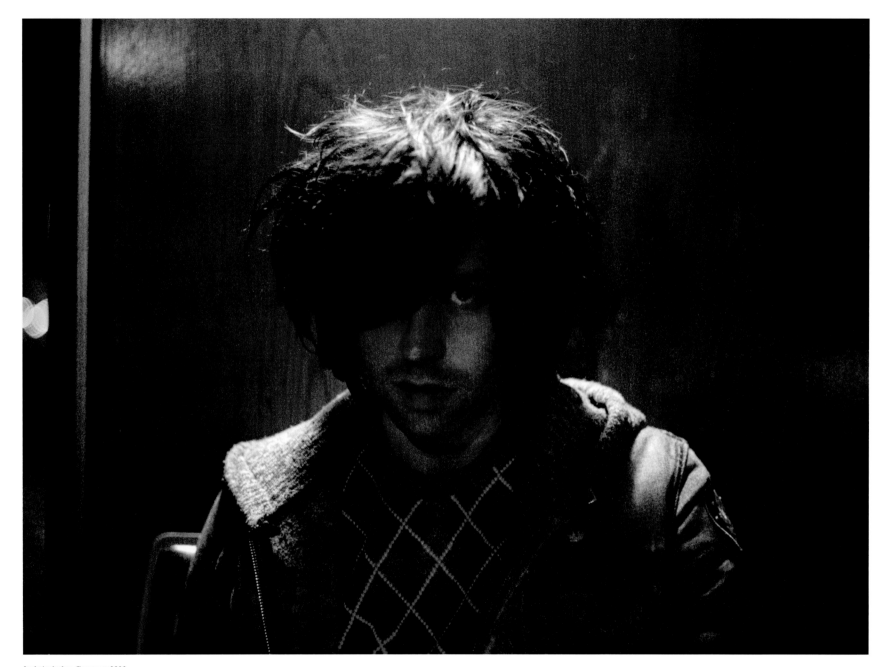

Ludwigshafen, Germany, 2006

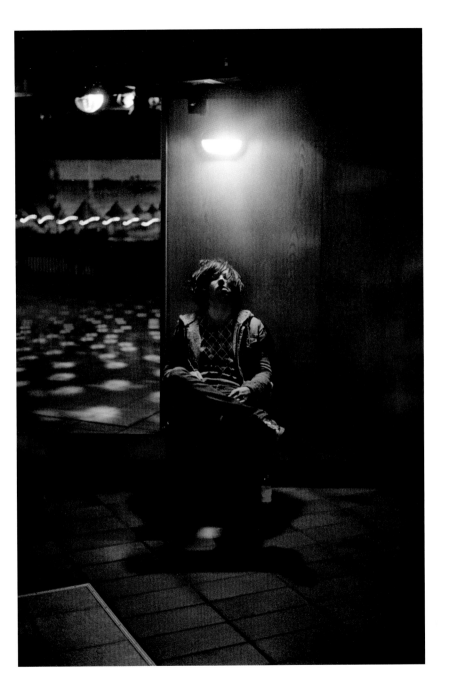
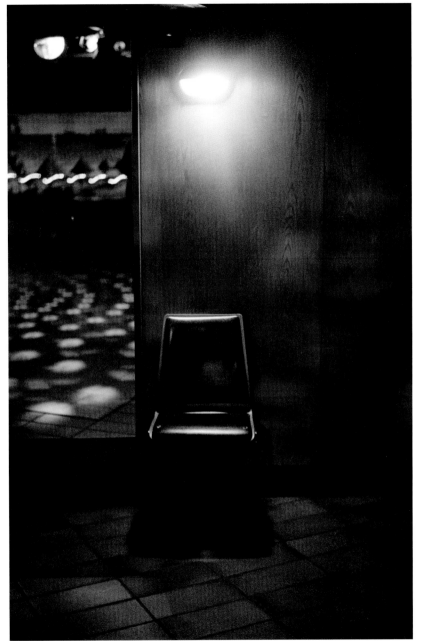

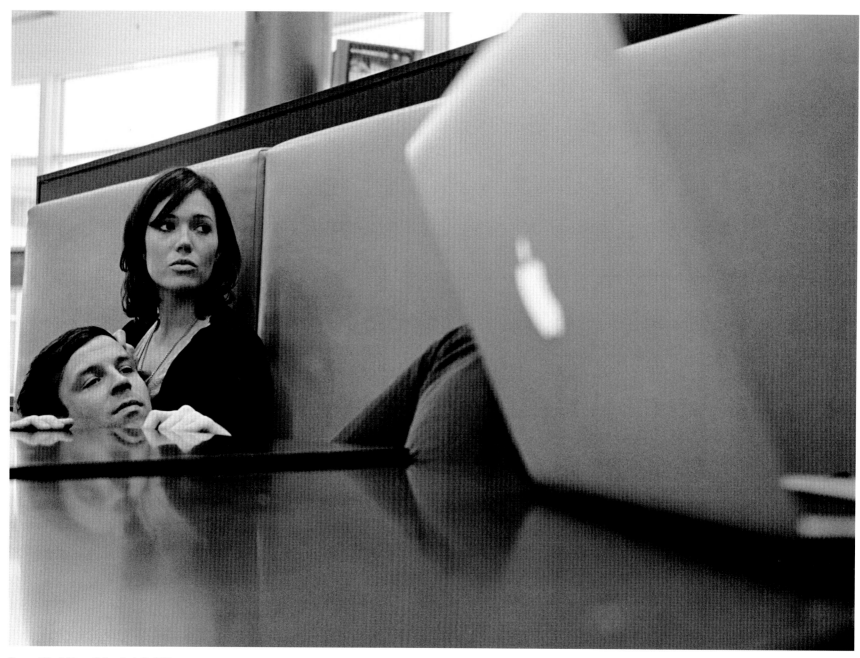

Ryan and Mandy Moore, Sydney, Australia, 2009

Brisbane, Australia, 2009

Tulsa, Oklahoma, 2009

Atlanta, 2009

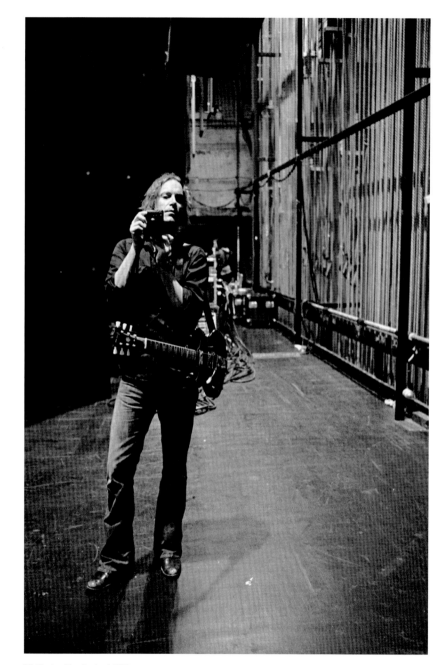

Wellington, New Zealand, 2009

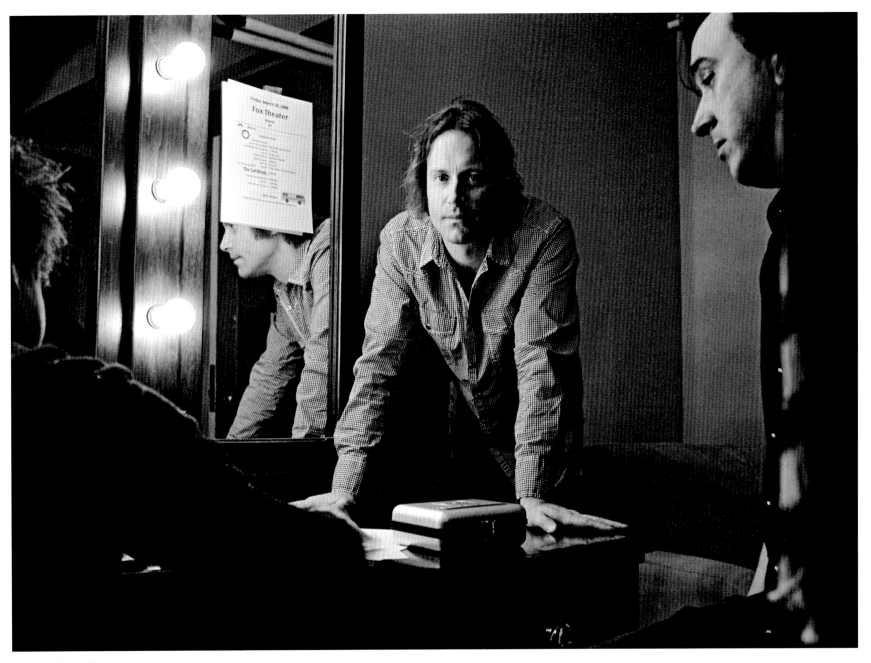

Fox Theater, Atlanta, 2009

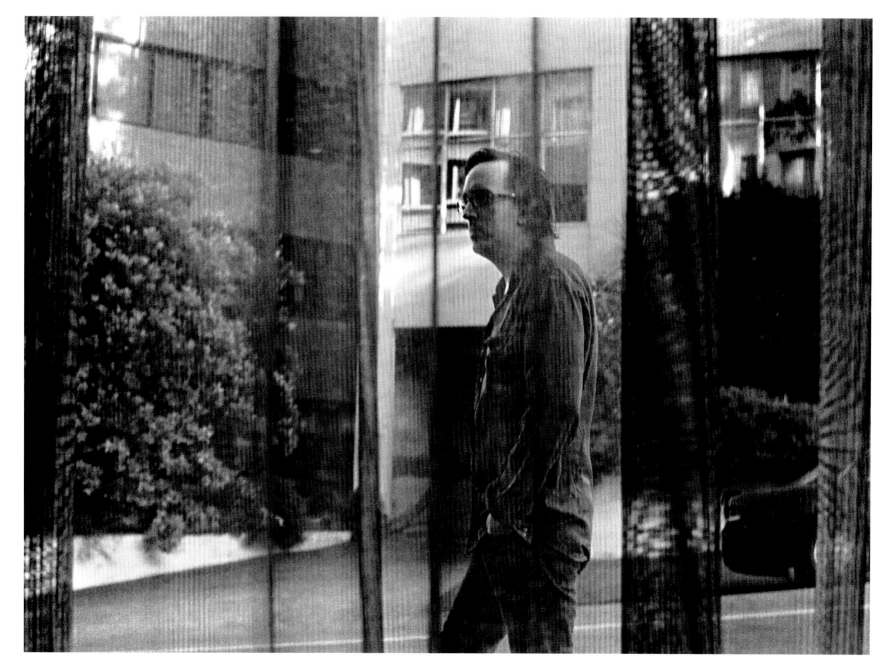

Wellington, New Zealand, 2009

Well, I guess I'm not surprised by much anymore. Of course, just when you think you've seen it all—surprise! But even as the guy who has been in the band the longest, I'm also the youngest next to Ryan (sorry, fellas, had to throw that in there!). So, I'm often the middleman/go-between/veteran band member who can hopefully translate the weird little idiosyncrasies that all bands deal with. But I'm also hyperaware of everyone else's experience and history before this band, and I respect the hell out of that. We are what we are because of those years when we all busted our asses touring in vans, just barely scraping by. But I don't feel like my tenure in this band puts me above anyone. We are all on a level playing field—and I'm always here for you guys if you need me. —Brad Pemberton

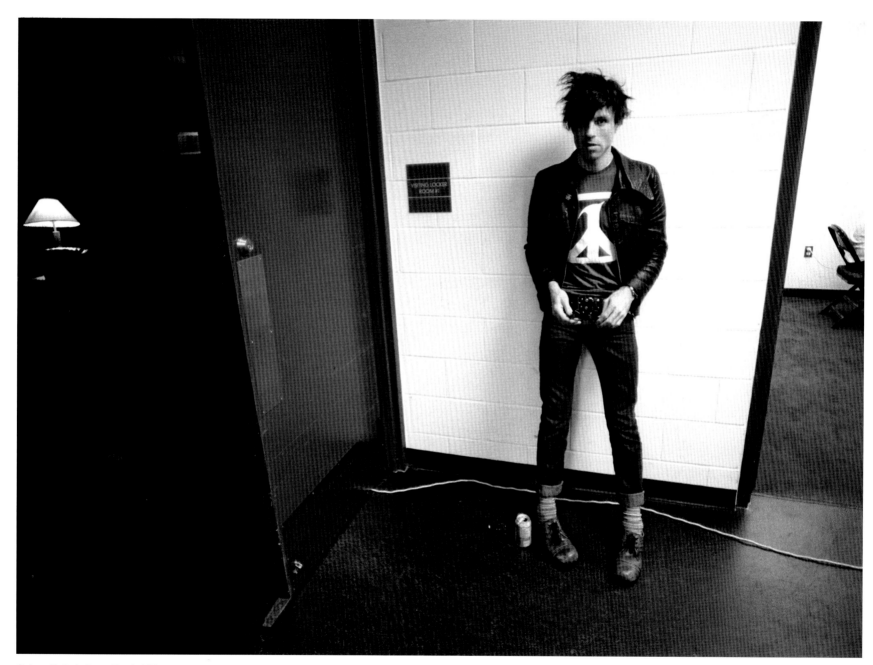

On tour with Oasis, Ottawa, Canada, 2008

Louisville, Kentucky, 2009

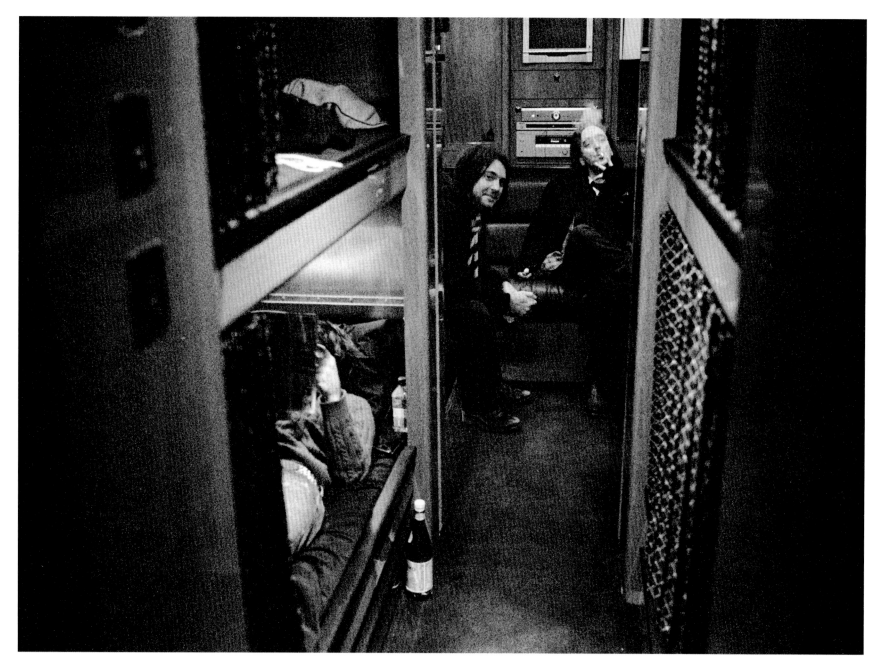

Somewhere in the U.S., 2008

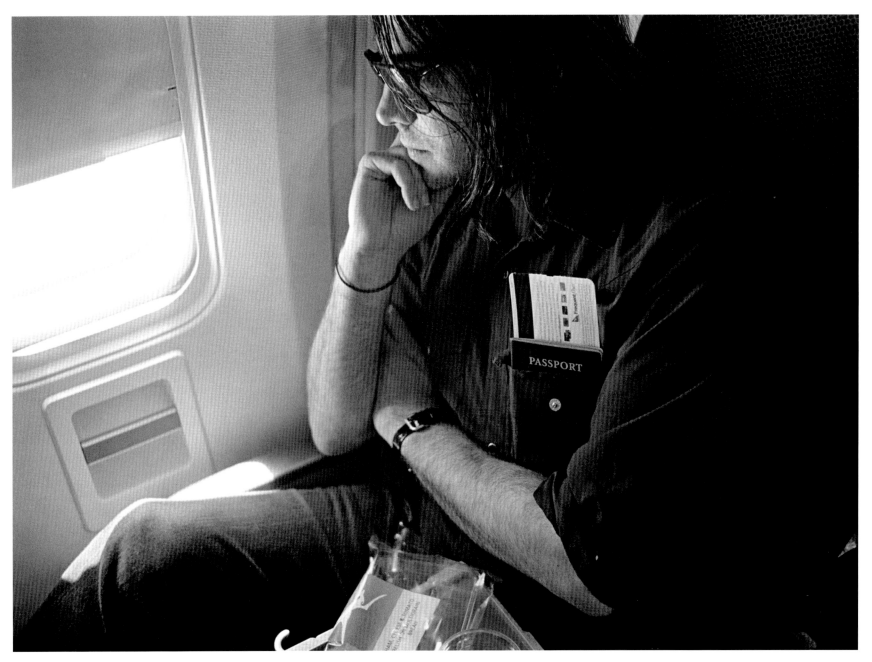

Over Australia, 2009

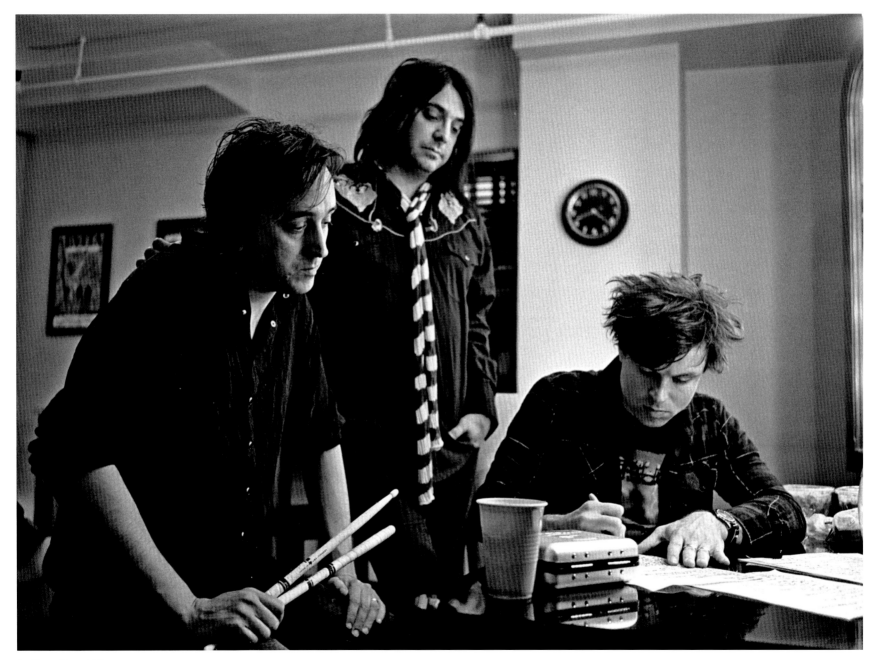

Fox Theater, Atlanta, 2009

Following page: Truckstop in Georgia, 2009

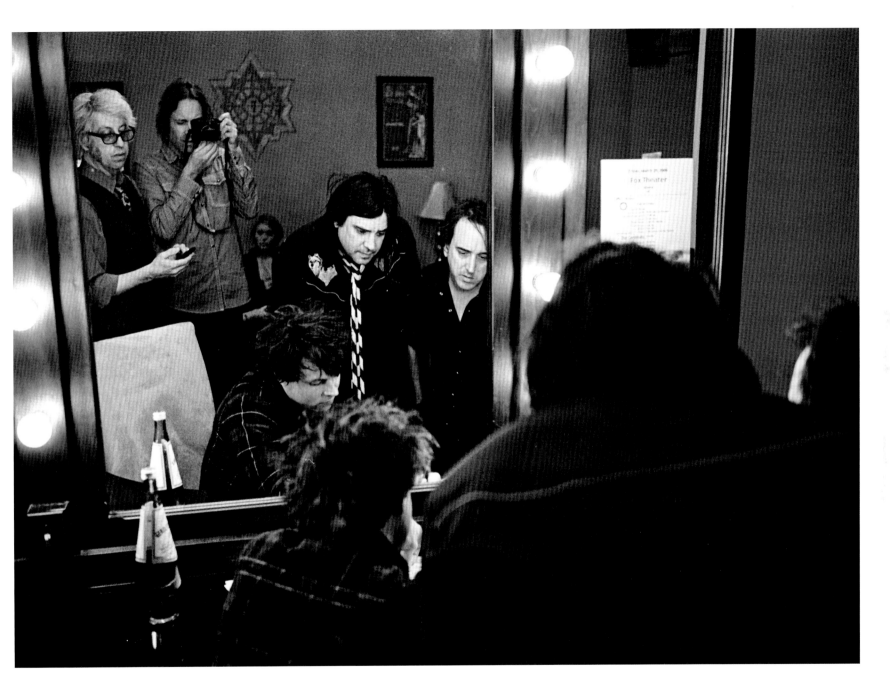

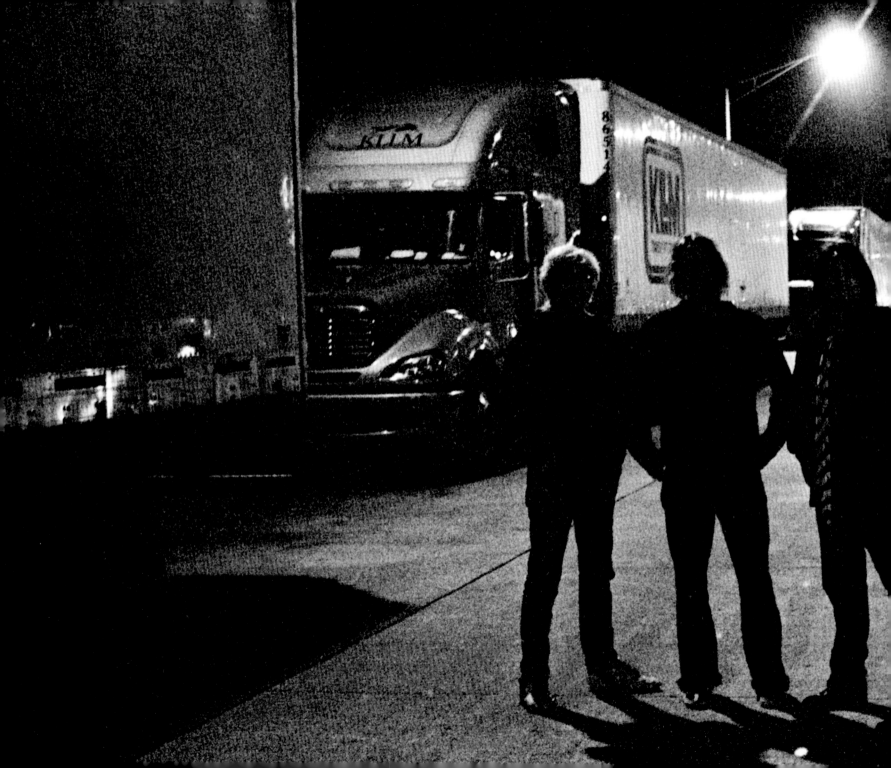

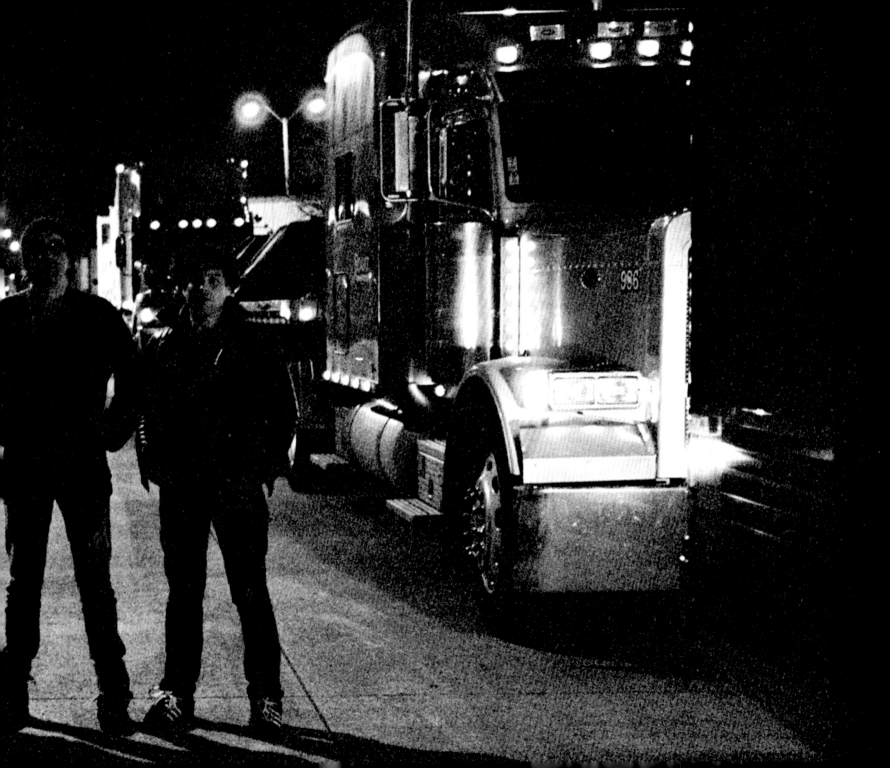

AFTERWORD
PHIL LESH

A great band, among many other things, is an indivisible unit—a self-contained universe—a single organism that creates its own reality, at least while the music is playing. The bond that draws the musicians together intensifies on the road (or in the studio, for that matter). The musicians must rely on their collective resources, both musical and personal.

When Ryan and I first met, in 2005, the Cardinals had just made their first record and were beginning to gel as a unit. With four years of growth, the band speaks with one voice and totally lives in the music.

One thing that can be said about Ryan—he brings the crazy. That is, the unexpected, the unpredictable. His whole life is as much an improvisation as any music he has ever played, and his fearless energy has permeated the whole band, as if by osmosis.

The ability to capture a precise image at exactly the right time is another facet of that improvisational spirit, allowing the prepared mind to reorient itself to any perceived change in tone, texture, or dynamic, and to instantaneously respond in kind. To capture the exact light and shade and color of a moment is to be fully aware of, and in, that moment. Only a musician could have captured the living experiences that look so vividly out at us from these photographs. Looking at Neal's shots, I can almost hear the music that's being played, or the joke that's being told.

This book makes me want to go back on the road . . . again.

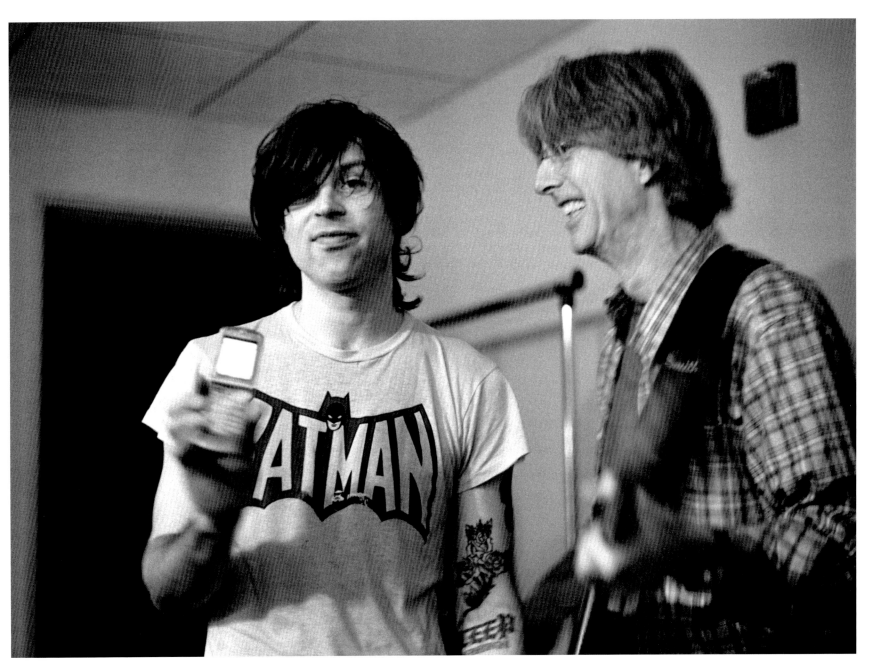

Ryan and Phil Lesh, Hollywood Bowl, Los Angeles, 2006

ACKNOWLEDGMENTS

Thanks to Christy Coleman for giving me my first camera and teaching me how to see, Laura Heffington, Patricia de Gorostarzu, Gary Waldman, Barbara Casal, Jenny Aurthur, Lex Armstrong, Piper Ferguson, Barbara Mcdonough, Shoko Tsuji, Yufu Morita, Andy West, Joanne Mildenhall, Kei Wakabayashi, Tatsuo Kotaki, Brittny Teree Smith, Shin Aso, John Silva, Michele Fleischli, Pete Smith, all at SAM, Dawn Nepp, Josh Grier, Michel Pampelune, Autumn and Jerry deWilde, Bobbie Gale, Jennifer Jenkins, Xiang and Juan Chen from Luster Photo Labs NYC, Simon Weller, Michele Augis, Jay Blakesberg, Dale Smith, Sonya Hay, Keiji Matsumoto, Goro Nakagawa, Kazutoshi Yasunaga, Danny Clinch, John Schulz, Suelain Moy, Joel and Carrie Swaney, John Carling, Doug and Tara, Wallace Lester, Mary Vidnovic, Sadie Starnes, Kevin Wells, Bill Valentine, Megan McIsaac, Karen Neasi, all of my friends in Japan who have supported my photography over the years, Ray diPietro, Frank Riley, Robie Willard, John Carter, Mark Messner, Paul Massaro, Kevin Carter, Dave Hamilton, Dee Stone, Elizabeth Pepin, Adam Haverstock, Colleen Gallagher, Dave Ford, Nat Baverstock, DJ Harmeling, Lee and all at Electric Lady, Christine Solomko, Kenny O'Connor, A&I Photographic Services, Chad W. Beckerman, and Roger Bova.

Massive appreciation and love to the Cardinals—Ryan Adams, Brad Pemberton, Jon Graboff, and Chris Feinstein—for the encouragement, the brotherhood, and the belief.

A final and special thanks to Tamar Brazis for helping me find the key and helping the bud to blossom. This book would not exist without you.

ABOUT THE AUTHOR

Neal Casal joined Ryan Adams and the Cardinals in 2005 and recorded three albums with the band: *Easy Tiger*, *Follow the Lights*, and *Cardinology*. He has also released nine acclaimed solo albums including *Fade Away Diamond Time*, *Basement Dreams*, *No Wish to Reminisce*, and most recently, *Roots & Wings*.

His photography was the subject of a solo show at the Bauhaus Gallery in Tokyo in 2008 and has appeared in many magazines such as *MOJO*, *Harp*, *Rolling Stone*, and *Spin*. He lives in Los Angeles.

Memphis, 2009

Editor: Tamar Brazis
Designer: Roger & Co.
Production Manager: Jacquie Poirier

Library of Congress Cataloging-in-Publication Data

Casal, Neal.
 Ryan Adams and the Cardinals : a view of other windows / by Neal Casal ;
 introduction by Ryan Adams ; afterword by Phil Lesh.
 p. cm.
 ISBN 978-0-8109-8266-6
 1. Adams, Ryan. 2. Cardinals (Musical group : Ryan Adams)
 3. Rock musicians--United States--Biography. I. Adams, Ryan. II. Title.
 ML420.A257C37 2009
 782.42166092'2--dc22
 [B]
 2009022032

All photographs by Neal Casal except page 114 and 145 by Jon Graboff, pages
154–155 by Ed Toney.

Printed and bound in China
10 9 8 7 6 5 4 3 2 1

THE ART OF BOOKS SINCE 1949
115 West 18th Street
New York, NY 10011
www.abramsbooks.com